A
HISTORY OF
ALABAMA'S
DEADLIEST
TORNADOES

DISASTER IN DIXIE

We thought you'd find
this really interesting!
Happy Father's Day!
— Greg (for Stacey
+ kids)

A
HISTORY OF
ALABAMA'S
DEADLIEST
TORNADOES

DISASTER IN DIXIE

KELLY KAZEK

THE
History
PRESS

Published by The History Press
Charleston, SC 29403
www.historypress.net

First published 2010

Manufactured in the United States

ISBN 978.1.59629.911.5

Kazek, Kelly.
A history of Alabama's deadliest tornadoes : disaster in Dixie / Kelly Kazek.
p. cm.
Includes bibliographical references.
ISBN 978-1-59629-911-5
1. Alabama--History--Anecdotes. 2. Tornadoes--Alabama--History--Anecdotes. 3.
Disaster victims--Alabama--Biography--Anecdotes. 4. Alabama--Biography--Anecdotes.
5. Birmingham Region (Ala.)--History--Anecdotes. 6. Huntsville Region (Ala.)--History--
Anecdotes. I. Title.
F326.6.K39 2010
976.1--dc22
2010014770

This book is dedicated to those people whose stories are told on the following pages: the victims, survivors and heroes of Alabama's deadliest tornadoes, and to the meteorologists who work toward a better understanding of these powerful storms.

And to my grandmother, Shannon Blackburn Gray, whose words inspired me.

CONTENTS

ACKNOWLEDGEMENTS

No book is ever written without help, but a book chronicling the impact of disaster on people's lives requires the assistance of many people.

While this book focuses mostly on personal stories and the aftermath of deadly tornadoes, I did spend some time learning about tornadoes in general, as well as the specific tornado incidents described on these pages.

I must thank those scientists whose goal is to learn more about tornadoes in an effort to save lives and who shared some of their vast knowledge with me: J.B. Elliott, who is retired from the National Weather Service in Birmingham but still keeps an eye toward the skies; Dave Nadler with the National Weather Service in Huntsville, who kindly invited me to visit the facilities; John DeBlock with the National Weather Service in Birmingham; and the staff of Limestone County Emergency Management Agency—Rita Wilson, Daphne Ellison and Spencer Black.

Thanks to those who were kind enough to give permission to use the incredible photos of tornado damage, family members or monuments to victims: Bill Wilson of the *Anniston Star* (various), Jim Pemberton (1989), Limestone County EMA (1974), the family of the late Larry Waldrup/ Waldrup Studios in Huntsville (1974), the City of Guin (1974), Dennis Burgess and the Albertville Historical Society (1908), Johnie Parker (1924), Analiese Schell (1932), J.B. Elliott (1977), Walter Kirkwood (1998) and the Reverends Dale and Kelly Clem (1994).

The inset photo on the back cover does not depict any of the storms that follow on these pages, but it is a tornado that struck Alabama. This storm

hit the Five Points community in January 2010, just as I was completing this project. While several homes were damaged, including that of a close friend, no one was injured. Thanks to Brandon Cripps for the amazing photo.

I also appreciate those who took photos specifically for inclusion in this book: Melanie Flanagan Elliott and Kim Rynders of the *News Courier*.

This book could not have been completed without the personal interviews and family and historical documents shared by the following: Dennis Burgess (1908); J.T. Collins and Johnie Parker (1924); Analiese Schell and Ray Atchison (1932); Sue Hilton Sellers and Elizabeth Sheetz (1956); Sandra Birdwell, Ananias Green, Donnie and Felica Powers, Faye McElyea, Walter McGlocklin, Marilyn McBay, Mike Kelley and Tom Griffis (1974); J.B. Elliot (1977); Kathy and Johnny Sharp, Fred and Mona Keith, Scott Gilbert, Shannon Dickinson, Jeff Scarborough, Marcia Scarborough Keller, Bridget McGary Sanders, Suzanne Keller, Tara Alt Brown and Jennifer Cosby (1989); the Reverends Dale and Kelly Clem (1994); Doris and Walter Kirkwood Sr., Terry Hyche, Jimmy Massey, H.C. "Hootie" Shoemaker, Walter Kirkwood Jr. and Brian McKay (1998).

I send great big hugs to my good friends who had the difficult task of being supportive as I wrote this book, as well as reading the manuscript and offering input: Michael and Melanie Flanagan Elliott, Sabrina Holt, Traci Parker, Cynthia Carpenter Slayton, Charlotte Fulton, Kim Rynders and Jean Cole.

I salute my commissioning editor, Will McKay, who has abundant patience.

Thanks to my family for the encouragement, particularly my brother and sister-in-law Kevin and Susan Caldwell.

Lastly, thanks to my "baby," Shannon, who had to put up with my moods when writing on a deadline. Love ya, babe. Mean it!

INTRODUCTION

Not long after dawn broke on the morning of November 16, 1989, I was drawn to the intersection of South Memorial Parkway and Airport Road in Huntsville, Alabama.

I used my relatively new press pass to get past the armed National Guard soldier stationed at the head of Airport Road, although I was not there as a reporter that day. I was there to bear witness to one of the most catastrophic events to hit this middle-class area of Alabama's fourth largest city.

The streets of south Huntsville were ones I had driven many times—on which, in fact, I had learned to drive. The sites along Airport Road were familiar ones. I'd shopped at the jewelry counter at Golbro and bought Cokes at Riley's Food Store.

But on this day, it was difficult to get my bearings. The landmarks of my youth were gone. In their place were piles of lumber and twisted metal. In the days following the horrific F4 tornado of November 15, 1989, almost everyone interviewed would liken Airport Road to a war zone.

It had become cliché for tornado damage sites, but it was accurate nonetheless. In the span of a few minutes, churches and schools were destroyed, an apartment complex was reduced to rubble and more than one hundred cars were tossed into heaps like toys; 21 people were dead and 263 more were injured.

It would be many years before Huntsville would recover.

I had been a newspaper reporter for about two years, and it was the first time I had witnessed the aftermath of such wrath. It would not be the last.

Over the course of the next twenty-one years, I would bear witness to countless tragedies, both natural and man-made: a teen murdered by her father, children killed in car crashes, a woman drowned after falling from the Tennessee River Bridge.

I would photograph the Gulf Shore after it was devastated by Hurricane Ivan and make three trips to the coasts of Alabama and Mississippi to record Katrina's impact. They are images I will not ever forget.

Some people think that reporters become cold, insensitive to the impact of tragedy. The reality, though, is often different.

On the outside, we journalists must remain coolly objective in order to get the facts of a story. But on the inside burns the desire to record the human stories—perhaps in the hopes that history won't repeat, or to remind readers that the impact of tragedy continues long after camera crews have left or maybe just so that future generations will have a chance to know a person who no longer walks among us.

Sometimes after the details of a story are written and the story is filed, the tears come.

I consider myself a recorder of history. Though writing about death and destruction wrought by Alabama's deadly tornadoes is a grisly task on some level, I do not see the stories on these pages as dark ones. I see them as tales of hope and of people reaching for the light after the storm.

The people described in these stories are survivors, whether they came out whole or disabled, filled with fear or with hope or were left grieving loved ones, their homes or simply their perspectives. All were changed when fury descended from the Alabama skies. That is what makes their stories meaningful.

An important note about these stories: Details vary of the tornadoes that have struck Alabama, even among official sources. When writing about the more historic storms in particular, I had to rely on newspaper accounts and reports, which, when catalogued within hours of a storm, may not have been accurate. The death tolls, numbers of injured and extent of damage I used were typically the numbers on which the majority of weather experts and government officials agreed.

Any Fujita scale rankings used for historic storms were assigned by weather experts after 1971, when the scale was created by Theodore Fujita, and were designated based on newspaper accounts and weather reports of damage. Before 1950, no official records of tornadoes were kept by any agency. In the 1950s, tornadoes were studied and their impact recorded by the United States Weather Bureau. Tornadoes between 1950 and 1971 were given Fujita scale rankings based on those reports.

The human stories recorded on the following pages from tornadoes before 1950 are based on newspaper accounts and historical and family records. People involved in tornadoes after 1950 were personally interviewed for this book. Their memories, like all of ours, may not be perfect, but what cannot be ignored is that all of them can recall the horror and fear caused by deadly tornadoes.

It is the people who give these stories their greatest impact.

I hope I have done them justice in the telling.

Chapter 1
ALABAMA, STATE OF CHAOS

A History of Deadly Tornadoes

On Valentine's Day 2010, Kathy Sharp of Huntsville, Alabama, found two candy hearts on a table in her home in which she makes the flower arrangements that she sells.

One said, "Marry Me," and the second said, "Say Yes."

The hearts were from her husband, Johnny, who was asking if Kathy would agree to renew the vows they had made twenty-two years before.

Kathy said yes. On their twenty-fifth anniversary on April 29, 2013, the couple will hold a ceremony.

The renewal not only symbolizes the couple's love for each other but is also recognition that the Sharps' marriage has survived—though few thought that it could possibly withstand the tragedy of November 15, 1989, when a tornado left Kathy paralyzed and tore the newlyweds' lives apart.

With little warning, the storm struck at dusk on a fall day, demolishing a school, churches, an apartment building and businesses along busy Airport Road in south Huntsville, making cars into heaps of scrap metal and bending huge metal utility poles like plastic straws.

When the winds finally stilled, 21 people were dead, and 463, including Kathy Sharp, were injured.

She was paralyzed.

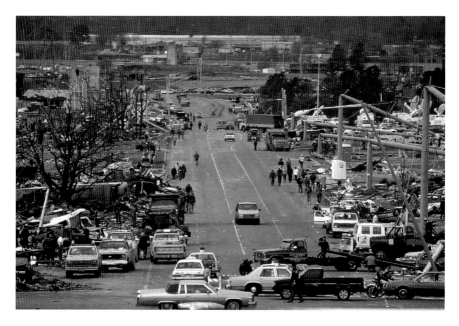

A view of devastation on Airport Road from atop Carl T. Jones Drive after the November 15, 1989 tornado hit Huntsville. *Courtesy of Bill Wilson/the* Anniston Star.

DIXIE ALLEY

Alabamians are accustomed to praying. They pray for their babies to be healthy, for a good cotton harvest and for the Crimson Tide or Auburn Tigers to win. And dozens of times each spring and fall, when they are chased into hallways, closets and basements by the chilling sound of tornado sirens, they pray for God to stop the winds.

Most times, when the winds finally still and people emerge unscathed, they find that their prayers have been answered: no one was hurt—this time.

The time spent huddled together with emergency lights and weather radios—and maybe a box of MoonPies—was just another form of family bonding. Too often, though, those who are lucky emerge from hiding to find that their neighbors have lost their possessions, their homes and, sometimes, their lives.

In Alabama, tornadoes have changed thousands of lives. Most people think of states like Oklahoma, Kansas and Nebraska when they think of tornadoes. But Alabamians, particularly in central and northern parts of the state, know that spring brings dogwoods and azaleas as well as the sound of tornado sirens. November brings a second tornado season.

Schoolchildren are accustomed to marching into hallways and covering their heads, so they will know what to do if a tornado comes near their schools. At times, classes and after-school events are canceled so that children will be home with their parents, and hopefully safe, when a storm hits.

Dozens of times each year, television shows will be interrupted by continual storm coverage, in which television meteorologists plot the courses of tornadoes or potential tornadoes in an effort to get warning to those in their paths.

Natives know what it means when the weather becomes unseasonably warm and the sky glows with an unnatural greenish tint. They know that they need to turn on the news.

To someone living outside a tornado-prone state, the frequent warnings may seem dramatic. But anyone who has lived in Alabama for any number of years knows that there is reason to fear an approaching tornado. They almost always bring destruction. Too often, they bring death.

Alabama ranks thirteenth in the number of tornadoes that strike states each year, but it ranks third in the number of deaths caused by tornadoes.

In addition, Alabama has experienced more F5 tornadoes, the most intense, than any state but Texas, Kansas and Iowa. Alabama has had five F5 tornadoes, as have Iowa and Kansas. Texas is the only state to experience six F5s. Ohio and Oklahoma have experienced four F5s each.

Northern and central Alabama are particularly susceptible to strong tornadoes because that is where the warm, moist air from the Gulf of Mexico meets the dry, cold air from the north. When hot air rises, it can begin to circulate if the winds are coming from different directions. A cone or funnel then forms in the cloud; if the funnel reaches the ground, it becomes a tornado.

The most common season for tornadoes in Alabama is spring, particularly in March and April, but Alabama has a secondary tornado season in November. The devastating F4 that struck Huntsville in 1989 was the strongest ever experienced in the state in November. For several years in the early 2000s, more tornadoes occurred in November than in spring.

Tornado season in the Plains states comes later. But in Alabama, March and April are unpredictable change-of-season months, with extremes including rare blizzards in March and an April record high temperature of ninety-four.

Despite the devastation caused in this state, Alabama is not within the commonly known Tornado Alley. The alley is not a meteorological designation but rather is a colloquialism used to refer to states in which tornadoes occur most frequently, typically between the Rocky Mountains and Appalachian Mountains.

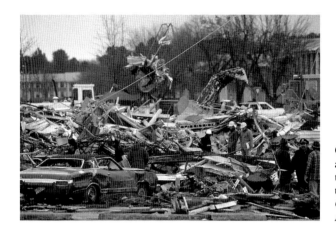

Clean-up crews have a daunting task in the aftermath of the tornado in Huntsville. *Courtesy of Bill Wilson/the* Anniston Star.

More recently, the phrase "Dixie Alley" has been used to refer to the deadly paths tornadoes take through the Southeast. Dixie Alley refers to the lower Mississippi Valley regions of Arkansas, Mississippi and Louisiana; the upper Tennessee Valley region of north-central to northern Alabama; and Georgia.

While tornadoes are less frequent in these states than in the traditional Tornado Alley states, Alabama and Mississippi have experienced more tornado fatalities than have the Plains states, with the exception of Texas, which has a much larger population.

WHY ALABAMA?

The most frequent meeting places of cold air from the north and warm, moist air from the gulf are along and north of Interstate 59, which runs from Slidell, Louisiana, to Interstate 24 in Georgia, said John DeBlock with the National Weather Service in Birmingham.

"The cold fronts from the north peter out as they head farther south, and that's where they tend to weaken," he said. "But tornadoes can happen anywhere at anytime."

With increased awareness and modern technology, meteorologists can now predict storms in time to get warning to those in their paths. Still, such strong storms are not entirely predictable.

"Tornadoes have so much energy, it's difficult to get actual measurements. Tornadoes are just as unpredictable now as they once were, but our understanding of them has certainly improved," said Dave Nadler with the National Weather Service in Huntsville. "The difference in the technology

we had then and what we have now is night and day." Across the country, 122 Doppler radars help storm trackers spot pending bad weather.

In Alabama, many factors lead to the high death tolls caused by tornadoes:

1. The Southeast, especially Tennessee, Mississippi and Alabama, has one of the highest concentrations of mobile home parks in the country.
2. Alabama has a greater population density than midwestern states.
3. Alabamians are less likely to have storm shelters in their homes.
4. The state has a large number of nocturnal tornadoes, when people would be sleeping and unaware of the approaching danger.

In 1924, a tornado swooped from the sky just before midnight and, without warning, struck one farmhouse in Elkmont in rural Limestone County. An entire family of eight was killed. No other homes were hit.

"Even today, on a farm asleep at night, there is a likelihood a tornado could hit without warning," DeBlock said. "That is why weather radios are so important." Of the tornadoes that hit Alabama, 36.1 percent come in the dark, Nadler said. The peak time for tornadoes to strike in Alabama is between 4:00 p.m. and 5:00 p.m. until 9:00 p.m.

"There is no clear-cut explanation for why more tornadoes hit after dark here," he said.

5. The terrain in central and northern Alabama is mountainous and heavily wooded, meaning that tornadoes can sometimes approach stealthily.

"In the Midwest, you have greater visibility. You can see forever," DeBlock said. "It's harder to see tornadoes coming here because of all the trees."

6. People grow complacent.

Forecasting is not a perfect science, DeBlock said; sometimes predicted tornadoes do not materialize. "It's plain to us there is a bit of a disconnect in how people interpret warnings," he said. "Communicating the threat and understanding how people respond is under increased interest. We're trying to determine how and why people respond."

Experts at the Storm Prediction Center in Norman, Oklahoma, continually evaluate the threat of severe weather up to seven days in advance and can see if there is a potential for a significant weather episode.

"We have confidence we're catching the large events," DeBlock said. "They present themselves in the atmosphere with obvious symptoms. The tough ones are the marginal ones. We understand what the ingredients are, but we don't have the recipe."

No matter how accurate the science of forecasting becomes, DeBlock said that people should be aware that there is no way to hide from the most intense of tornadoes, except in underground shelters. "An EF5 can take a home and strip the foundation clean. There are no good places to be. If it hits anything, there will be fatalities."

SCHOOL DEATHS

In March 1944, twelve-year-old Jimmy Mitchell was killed inside a three-teacher school in Pine Grove, Alabama, sixty miles northeast of Birmingham. Fifteen of Jimmy's classmates were injured.

Jimmy was one of many Alabama students killed by a tornado while in school over the years. From 1884 to 2007, forty-five tornadoes caused 271 school fatalities in the United States. Alabama has the highest number of tornadoes (eight) to cause deaths at schools; Illinois is second with six, and Missouri and Oklahoma rank third with four each.

Illinois has the most tornado deaths (ninety) to occur inside schools, largely because sixty-nine students and teachers were killed there during the 1925 Tri-State Tornado, which still ranks as the deadliest tornado outbreak in our nation's history.

The southeastern United States has experienced twenty-three tornadoes that caused deaths in schools, more than any other region in the country. In many instances, tornadoes have demolished Alabama schools after students had gone home and, thankfully, no students were killed.

After tornado warnings were implemented in 1950 and watches in 1952, school fatalities decreased. A watch means that conditions are favorable for the development of tornadoes. A warning means that a tornado has been spotted on the ground or that radar indicates that a tornado may be forming. Emergency sirens sound when a tornado warning is issued.

At about 1:30 p.m. on Thursday, March 1, 2007, students at Enterprise High School in Coffee County, Alabama, were following protocol. They took cover in the hallways of the school when tornado sirens sounded. But the EF4 would prove too strong. It would bring the worst school disaster in Alabama history.

When the winds from the devastating tornado stilled, 8 students were dead. The school was destroyed. Another person died elsewhere in town; 121 people were injured, and the town of Enterprise had sustained $307 million in damage.

A memorial would be built at the site where the hallway roof had collapsed, killing Michael Tompkins, seventeen; Jamie Ann Vidensek, seventeen; Michelle Wilson, sixteen; Katie Strunk, sixteen; Michael Bowen, sixteen; A.J. Jackson, sixteen; Ryan Mohler, seventeen; and Peter Dunn, sixteen. They would become known as the "Enterprise Eight." A scholarship also was established in their honor—the In Memory of the Enterprise Eight fund.

In the wake of the storm, celebrities hosted benefits, and the town rallied to help build a new school. Classes were held at a local college until the high school could be rebuilt at a new site. It would take three years. The $80 million three-story school will open to students in August 2010.

THE FUJITA SCALE

In 1971, Theodore Fujita (1920–1998) developed a scale to rate the intensity of tornadoes. The Fujita scale takes into account damage tornadoes inflict on structures and vegetation.

That same decade, Ted Fujita would use his studies of Alabama tornadoes to further scientists' understanding of the impact of severe storms. In Guin and Tanner in 1974, and in Birmingham in 1977, he encountered the devastation of three of the most destructive storms ever witnessed.

Between 1971 and 2007, meteorologists and engineers assigned official rankings between F0 and F5 based on ground or aerial damage surveys, as well as ground-swirl patterns, radar tracking, eyewitness testimonies, media reports and damage imagery. An F5 tornado had winds from 216 to 318 miles per hour.

Scientists applied Fujita rankings to tornadoes that occurred between 1950 and 1971 by studying reports from the United States Weather Bureau. Before 1950, no official records were kept on tornadoes. Any Fujita scale rankings for tornadoes before 1950 were assigned based on media accounts of storm damage.

On January 31, 2007, the Fujita scale was changed slightly to better identify a tornado's intensity. Unlike the original scale, the Enhanced Fujita, or EF, scale takes into account the quality of construction of the structures demolished in storms. Not as much wind is required to demolish a poorly built shed as a sturdy building.

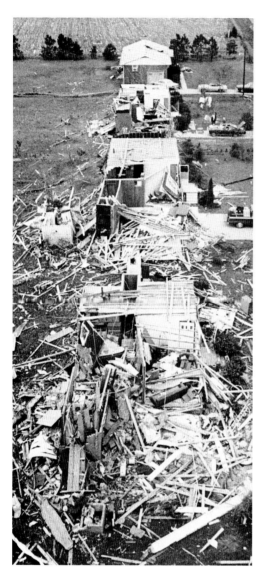

Tanner Crossroads was struck twice on April 3— once by an F4 and again by an F5. *Courtesy of Larry Waldrup/Waldrup Photography, Huntsville.*

An EF5 tornado has winds of 200 to 322 miles per hour. Less than 0.1 percent of tornadoes are EF5s.

SOME OF ALABAMA'S DEADLIEST EVENTS

One of the earliest recorded tornado outbreaks occurred on February 19 and 20, 1884. Called the Enigma Outbreak, it is thought to be among the most widespread and deadliest outbreaks in American history.

Because scientific weather records were not kept at the time, the exact number of tornadoes and resulting fatalities are unknown, which is why it is referred to as the Enigma Outbreak. Study of news accounts at the time shows that tornadoes struck that day in Alabama, Georgia, Illinois, Indiana, Kentucky, Mississippi, North Carolina, South Carolina, Tennessee and Virginia. The low estimate of the number of tornadoes is fifty, but most scientists believe there were more than sixty. Fatalities were estimated between 178 and 1,200, with the high end more likely.

Alabama was devastated as several waves of storms hit the state on February 19 during the fifteen-hour outbreak, including two tornadoes that were ranked F4s based on accounts of destruction.

The *Fort Wayne Daily Gazette* in Indiana reported under the headline "The Great Gale" on February 20, 1884:

> *A cyclone swept through Cahaba valley yesterday noon. It is reported thirteen were injured in one community…Three miles south of Leeds the house of John Poole was blown away and a son, daughter and child of the tenant instantly killed. Poole, his wife and four children were badly injured. The residence and premises of Dr. W.F. Wright, a railway contractor, were demolished. The body of Dr. Wright's mother was found one hundred yards from the house fearfully mangled. Annie, Jennie, Thomas, James, and Edward, children of Dr. Wright, have arms or legs broken. Harriet McGrew, a cook, was killed. Of twenty-four cows, two wagons and three horses on the place nothing remained but the carcasses of the horses. The house of a man named Kerr took fire and was blown away, and Mrs. Kerr was fatally hurt. The railway for several miles was strewn with debris.*

During the Enigma Outbreak, tornadoes to hit Alabama included an F2 that struck at 12:30 p.m. near Rockford in Coosa County; a storm of unknown ranking that hit Perry County, causing one death; an F4 that hit at 1:20 p.m. south of Birmingham and continued to Branchville in Jefferson and St. Clair Counties, causing thirteen deaths; a tornado of unknown rank that hit Guntersville and then Cullman and Marshall Counties; an F2 that hit at 1:45 p.m. in Talladega and Calhoun Counties; and an F4 that struck at 2:30 p.m. and continued from Jacksonville, Alabama, to Cave Spring, Georgia, causing thirty deaths, including ten near Cross Plains (now called Piedmont) and fourteen at Goshen.

In addition to the Enigma Outbreak, these tornadoes caused twenty or more deaths in Alabama, according to the Tornado Project. The following list includes details of individual tornadoes within outbreaks on the same day:

- **January 22, 1904** (just past midnight): 36 killed and 150 injured. Leveled northern half of Moundville. Half of the population was killed or injured; bodies were blown for half a mile.
- **April 24, 1908** (2:40 p.m.): 35 killed and 188 injured. Most of Bergens was destroyed, with 12 killed there; 15 died at Albertville.
- **March 21, 1913** (4:30 a.m.): 27 killed and 60 injured. Lower Peach Tree in Wilcox County was devastated.
- **May 27, 1917** (8:45 p.m.): 27 killed and 100 injured; 9 were killed in Sayre and 17 in Bradford.

- **April 20, 1920** (8:00 a.m.): 44 killed and 400 injured. This storm hit Mississippi and then caused fatalities in four Alabama counties.
- **April 20, 1920** (10:00 a.m.): 21 killed and 50 injured. Struck Winston County, especially the Arley-Helicon area.
- **April 20, 1920** (12:30 p.m.): 27 killed and 100 injured. Gurley and Brownsboro in Madison County were struck.
- **March 21, 1932** (4:00 p.m.): 37 killed and 200 injured. The northwest edge of Tuscaloosa and the business district of Northport were devastated.
- **March 21, 1932** (4:30 p.m.): 49 killed and 150 injured; 21 were killed in rural Perry County, including seven in one family.
- **March 21, 1932** (5:30 p.m.): 31 killed and 200 injured. This tornado moved parallel to the previous tornado that day. Most fatalities were at Stanton and Lomax in Chilton County.
- **March 21, 1932** (7:10 p.m.): 41 killed and 325 injured; 29 people died in the northern part of Sylacauga.
- **March 21, 1932** (8:00 p.m.): 35 killed and 500 injured. Rural communities in Jackson County were hit.
- **May 5, 1933** (2:30 a.m.): 21 killed and 200 injured. Brent, Colemont and Helena in Bibb and Shelby Counties were hit.
- **February 12, 1945** (5:22 p.m.): 26 killed and 293 injured. Chisholm, north of Montgomery, was struck.
- **April 15, 1956** (3:00 p.m.): 25 killed and 200 injured. McDonald Chapel near Birmingham was devastated.
- **April 3, 1974** (5:50 p.m.): 28 killed and 260 injured; 14 died near Moulton, including 6 in one family and 4 in another.
- **April 3, 1974** (7:50 p.m.): 30 killed and 280 injured; 20 deaths occurred at Guin in Marion County in a matter of seconds.
- **April 4, 1977** (5:00 p.m.): 22 killed and 130 injured. Hit the Smithfield suburb northwest of Birmingham.
- **November 15, 1989** (4:30 p.m.): 21 killed and 463 injured. Hit south Huntsville during the beginning of rush hour; 12 people died while in their cars.
- **March 27, 1994** (10:55 a.m.): 22 killed and 159 injured. Struck Goshen United Methodist Church in Piedmont during Palm Sunday services.
- **April 8, 1998** (6:42 p.m.): 32 killed and 258 injured. Small communities southwest of Birmingham were hit.

Chapter 2
1908 DIXIE SUPER OUTBREAK

"Unprecedented in the History of the State"

The citizens of Albertville were going about their daily business on April 24, 1908. It was an unseasonably warm Friday, and people were looking forward to the weekend. Although the skies were cloudy, the temperature that morning was in the sixties, reaching the high eighties by noon.

Some residents may have read the reports that thirteen people had been killed in Texas when tornadoes hit two towns there the day before. But Texas was far away, and in Albertville, there seemed nothing more dangerous on the horizon than a few thunderstorms.

Rena McCord, wife of Edgar Oliver McCord, was home with the children. Rena and E.O.—a local attorney who had served as mayor and newspaper editor in Albertville—had five children: Minnie Lee, Eric Oliver, Frank Henry, Roy Davis and Winnie Ruth.

From the distance, to the west, came the low rumble of thunder. For almost three hours, the thunder drew closer.

At about 3:50 p.m., W.J. Nash of neighboring Highmound was working outdoors when he heard a shout from his brother, whose home was nearby. When Nash raised his eyes, he saw his brother pointing to the southwest.

Nash later wrote an account of what he witnessed that day for the United States Weather Bureau: "I looked and beheld one of the grandest sights, in its awfulness, I ever looked on in my life. A great cloud, funnel shaped, with the small end dragging the ground, and the large end reached far up in the heavens."

Nash estimated that the twister was 225 yards in diameter at the small end and as much as a mile wide at its top. It was black, like dense smoke, he recounted:

*I noticed that on its south wing it threw out great arms or bulges of smoke.
This it did not do on the north wing. These arms did a great deal of
damage to timber and houses for a mile from the main track. The arms only
would leave the main track for a moment and then they would return to the
storm again. On examination, I found that almost everything was taken up
in the center of the storm.*

The massive twister was headed toward Albertville.

When it struck at about 4:00 p.m., it brought death to the McCord
family and many other residents in the town. It destroyed a large portion of
downtown Albertville's business district and many surrounding homes.

Fifteen were killed in the small agricultural community. Hundreds were
left homeless.

Albertville in Marshall County and the tiny community of Bergens
(sometimes spelled Bergen in historical records) in Walker County were
hardest hit that day in Alabama in what would become known as the Dixie
Tornado Outbreak.

At least 48 people died, and 260 were injured statewide when four tornadoes
hit Alabama that day. Between April 23 and April 26, sixteen tornadoes killed
320 across the South. One of the hardest-hit towns during the Dixie Outbreak
was Purvis, Mississippi. The tornado that hit Purvis and Amite killed a total
of 143 people along its path, including more than 55 people in Purvis, making
it one of the ten deadliest single tornadoes in American history.

Other tornadoes struck on April 25 and into April 26, causing death and
damage in towns in Mississippi, Alabama, Tennessee and Georgia.

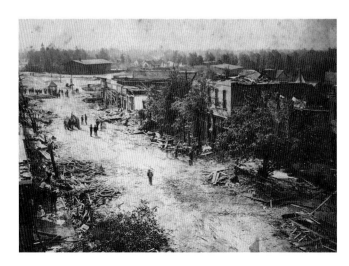

The business district
in downtown
Albertville was
devastated by the
April 24, 1908
tornado. *Courtesy
of Dennis Burgess,
Albertville Historical
Society.*

In Alabama, the tornado that stayed on the ground from Walker County to DeKalb County was estimated to be an F4 by modern scientists studying newspaper accounts of destruction. This tornado touched ground near Dora at about 2:40 p.m. and then continued northeastward until it lifted near Sylvania an hour and a half later.

According to the National Weather Service, twelve people were killed between Dora and Bergens. The tiny town of Bergens was destroyed.

The final toll from this tornado, which is plotted as a single tornado but could have been a family of tornadoes: two people dead in Warrior in Jefferson County, one near Royal and two in Wynnville in Blount County.

Under the headline "Trail of Death Across North Alabama: Much Loss of Life and Enormous Damage to Property," the *Fort Wayne Journal-Gazette* in Indiana reported on April 25:

> *A tornado passed over north Alabama late today, leaving a trail of death. It appeared at first at Bergens, a small town in Walker County on the Frisco railroad, at 2:30 o'clock, and many were injured…The storm appears to have cut a path about 500 feet wide and traveled from Bergen to Sylvania, a distance of about 125 miles in a little more than an hour.*

The tornado destroyed 237 buildings and caused more than $500,000 in damage, which is about $12 million in 2010. The National Weather Service in Birmingham states that, because of the scarcity of available data from the storm, it is likely that much more damage and fatalities occurred than are documented.

"A PITEOUS SPECTACLE"

In 1908, Americans were in love with the game of baseball; "Take Me Out to the Ballgame" was one of the year's most popular tunes.

The country was on the cusp of a new era of transportation. In January, Ferdinand von Zeppelin announced plans to build an airship to carry one hundred passengers. Before the year was out, the first passenger flight would take place, the *Lusitania* ocean liner would set a record crossing the Atlantic and the introduction of Henry Ford's Model T would make car ownership more affordable for the middle class.

In Albertville and most towns in Alabama, though, cars were rarely seen curiosities, and the common mode of transportation was a horse and buggy.

Albertville is located in Marshall County in northeastern Alabama. The 1900 Census reported about 24,000 residents countywide and 1,500 in the city of Albertville. Like most of northern Alabama, Marshall County is made up of small, forested mountains and picturesque valleys. The town's elevation is 1,054 feet.

Initially settled by Cherokee Indians, Albertville became a white settlement in the 1850s. Historians believe that Hernando De Soto crossed through what is now Albertville during his 1540 expedition.

During the Civil War, several small skirmishes occurred in the area.

The city was not incorporated until 1891. In 1908, most of its residents were cotton and corn farmers. According to the first volume of *History of Alabama and Dictionary of Alabama Biography*, 330,000 of Marshall County's 385,000 acres were used for farming.

The downtown area was made up of several brick and wooden storefronts and offices along a main street. Businesses included the Bank of Albertville; the *Albertville Banner*, a newspaper founded in 1097, a ginnery, an oil mill, a cotton seed meal plant; and a gristmill. Students attended the Seventh District Agricultural School. The faithful could choose from Baptist, Methodist Episcopal and Church of Christ congregations.

Quaint two-story homes lay just outside the business district, including the homes of the town's most prominent citizens—its doctors, lawyers and bankers.

E.O. McCord was one such citizen. Born in Georgia in 1867, McCord went to college and then came to Alabama to teach school. He became superintendent of public schools in Attalla before founding the *Marshall County News* in Albertville.

After two years as the editor of the newspaper, McCord realized that he wanted to be a lawyer. He returned to school, passed the bar in 1889 and opened a law practice in Albertville in 1993.

McCord was known as an upstanding citizen, volunteering his time to the Methodist Episcopal church and to several local men's fraternities. In 1904, the second volume of *Notable Men of Alabama* wrote of McCord: "Any project which has for its object the uplifting of humanity, whether local or State, finds in him an active supporter."

He served two terms as mayor of Albertville and penned the book *Minneola, the Queen of the Cherokees; a Thrilling Romance of Savage Days in Marshall County*, published in 1894.

Notable Men listed McCord's wife, Rena, and their five children. It states that Minnie Lee was a college student in 1904, but it is not known how many of the children were living at home when the tornado struck in 1908.

On April 24, McCord's home was destroyed, his teenage son was killed and his wife and another child were injured. The April 25, 1908 edition of the *Gadsden Daily Times News* reported: "Child's Frightful Death: Little Eric McCord became frightened and ran under the house and could not be persuaded to come out. When the house fell, he was crushed to death." Although this newspaper account seems to indicate that Eric McCord was a young child, he was a teen attending the Seventh District Agricultural School at the time of his death. His headstone is inscribed with a memorial from his schoolmates. The paper continued: "Mother is injured: Mrs. E.O. McCord, mother of Eric, was bruised and internally injured, but will recover…Toes torn out: Another of the McCord children was caught by the toes and two of them torn out."

One of the few positive stories in the news the next day reported that one of the youngest McCord children had, in his fear, crawled behind an upright piano in the home. When the house was destroyed over the family's head, the piano's legs collapsed, causing it to lean against the wall and shelter the child. The newspaper reported, "When the searchers raised it the little fellow scampered out."

Another Albertville family devastated on April 24 was that of John Decker. In one room of the Decker home, rescue workers found John Decker's wife and two children dead, while Decker and four other children were discovered seriously injured in another room. One of the injured children later died, according to newspaper accounts.

The *Gadsden Daily Times News* reported, "A piteous spectacle existed in the home of John Decker. In one room, lay the mother, dead, clasping to her bosom

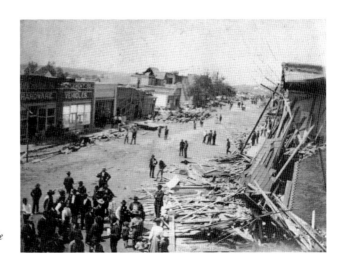

People survey the destruction in downtown Albertville following the 1908 tornado. *Courtesy of Dennis Burgess, Albertville Historical Society.*

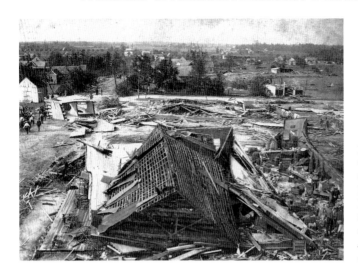

Fifteen people were killed when the 1908 tornado hit Albertville. Forty-eight died statewide. *Courtesy of Dennis Burgess, Albertville Historical Society.*

the body of a little child one year old, which she had tried vainly to shield." The two children who died near Mrs. Decker were both girls, ages one and three.

The *Gadsden Daily Times News* reported that Mrs. Fowler was in a room on the second story of her home. "The room was lifted bodily off and tossed out in the yard, but Mrs. Fowler escaped unhurt." Another newspaper account stated that the son of Ben Phillips was in the pasture when the storm hit. "The wind picked him up and deposited him upon an outhouse, which remained standing."

Near Albertville, a nine-ton oil tank was reportedly lifted into the air and carried about a half-mile before it was dropped. A train with nine freight cars was overturned and destroyed.

Colonel R.A. Mitchell, a member of Governor B.B. Comer's staff, reported:

> *The destruction of property here is, I think, unprecedented in the history of the state. I have never seen anything like it, so complete and absolute as to leave little of worth in the path of the storm through town. On viewing the wreckage, covering easily forty acres or more in the heart of town, it appears incredible that any living being could have escaped the fury of the storm and death.*

"HARVEST OF DEATH"

Rescue workers had to face heavy rains and a cold front when they arrived in Albertville.

By 5:00 p.m., Albertville's leaders sent an urgent telegram to Gadsden requesting immediate assistance. Later, urgent messages were also sent as far away as Birmingham and Chattanooga. Help was needed to search for the missing, catalogue the dead and care for the injured. The work was difficult. Debris was everywhere.

People in communities surrounding Albertville were ready to help. Some, who had family living in the town, came to Gadsden's railroad depot to await word of the storm's impact. It would be a long wait.

A train had just left the station as the storm hit, and the railroad superintendent John Lane wired the depot in Boaz and told the operator to tell the conductor to head quickly back to Gadsden.

The train pulled back into the station and was loaded with medical supplies and emergency workers, as well as two reporters from the Gadsden newspaper.

Finally, word came to Gadsden at 7:00 p.m., about three hours after the storm. That's when a special edition of the *Gadsden Evening Journal* hit newsstands.

Reporters had sent a two-hundred-word telegraph with the headline "All Physicians in Gadsden, Attalla, and many from Chattanooga are called for DIEING SCATTERED EVERYWHERE. Special Train with Doctors and NVRSES [*sic*] leaves Gadsden at 6:00 o'clock for Scene of Harvest of Death."

Reporters wrote: "There are a large number of people seriously injured. There are not sufficient doctors here to care for the injured and many may die if aid does not come soon. All the physicians of Gadsden, Attalla have been ordered to come here at once."

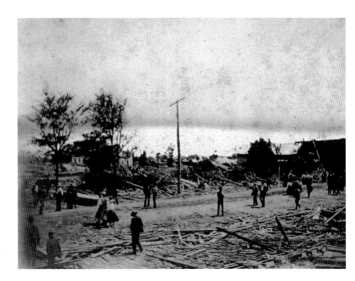

On some Albertville streets, no buildings were left standing.
Courtesy of National Weather Service.

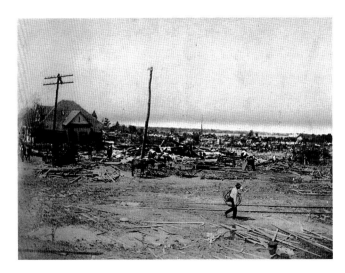

A handwritten note on this 1908 photo indicates that the home of Mrs. Mary Meigs was the only one remaining on this Albertville street after the tornado passed. *Courtesy of National Weather Service.*

It wasn't until 10:00 p.m. that the train arrived back in Gadsden and its passengers could give more details about what they had witnessed. Another hour later, the train began another run to Albertville with a detachment of Gadsden's Queen City Guards on board to help.

Albertville residents were grateful for the help. Hogan Jackson, bank president and treasurer of the relief committee, wrote a letter on April 27 to Gadsden mayor J.D. Dunlap: "For the stricken people of Albertville I thank the generous people of Gadsden through you. In this hour of sorrow we pray God to bless them."

The citizens of Albertville also dedicated themselves to helping their neighbors. It would be a long ordeal. Mrs. Hogan Jackson wrote in a letter to her mother on May 2:

> *Hogan has gone from a meeting of the relief committee tonight. He left the house as soon after the storm as he could to help those in distress and he has been working day and night ever since and has many of the citizens, even those who lost everything, have been doing every thing they could to help others. There was another death today, making a total of fourteen. There are two or three others the doctors are doubtful about. We are still distributing clothes and boxes keep coming in. We cannot realize what it is to be without a change of clothing and hundreds of people were left that way. They come to us and we give them what we can, a change of clothing anyway, or just enough to do until they can get someway to make more. And it is not poor people but some of the best people in town.*

"ITS GREATEST VIOLENCE"

The inhabitants of Bergens, a little village in Walker County located twenty-two miles northwest of Birmingham, were watching the skies in confusion earlier on April 24.

It had been cloudy all day, yet the temperature was warm and no rain fell. People wondered aloud throughout the day what kind of weather might be brewing.

Bergens was connected to Dora by the depot the towns shared along the Northern Alabama Railroad. While farming was also a major source of income in this part of Alabama, many residents worked in the nearby coal mines. About half the county's acreage—250,000 of 497,000 acres—was used for farming in 1908.

A weather observer, W.F. Lehman, published an article about the tornado that struck Bergens in the May 28, 1908 edition of the *Monthly Weather Review*. He wrote, "The people were wofully [*sic*] ignorant as to the character of a tornado and the direction from which to expect it."

Dora, which had about two thousand residents in 1908, was situated in a valley, which many of its residents believed was the reason Dora was spared most storms' wraths. The residents of Bergens would not be so lucky.

"Most of the people of Bergens recollect seeing the cloud coming, rushing to their houses for shelter (there were no tornado cellars), and having their houses blown down; all this happening within the space of fifteen seconds," Lehman wrote.

When the tornado, ranked by modern scientists as an F4, hit the tiny burg, twelve people were killed and nearly all its buildings destroyed or heavily damaged.

"Of the first group of ten houses, situated within 500 feet of the depot, eight were totally destroyed, including the depot, while one building almost in the center of the group escaped without any damage and a substantially built two-room house was thrown bodily on the railroad track 75 feet away from its foundation," Lehman noted.

Lehman reported that "ten empty boxcars on the side of the Northern Alabama Railroad were struck; three were overturned and seven were blown about, with heavy parts carried 100 feet away."

Lehman believed two tornadoes had joined just before hitting Bergens: "It was not until the storm was joined, about a mile southwest of Bergens, by another black mass of clouds, smaller in extent and moving in a more easterly direction, that it developed its greatest violence."

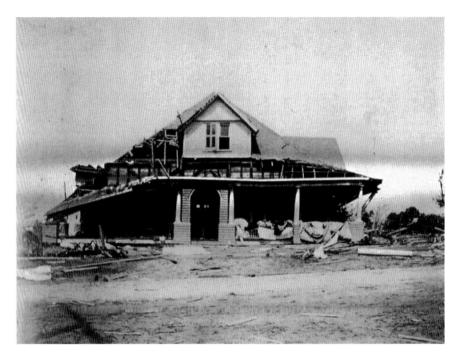

A note on this photo states that this is the home of M.G. Ship on Broad Street in Albertville. It was badly damaged by the 1908 tornado. *Courtesy of National Weather Service.*

LEGACY

Today, Dora is a sleepy town of about 2,500 residents. The tiny community of Bergens exists now only as a memory. A local history book includes photos of devastation from the 1908 tornado, but the town's place in history is largely forgotten.

The people of Albertville, however, have been reminded of the tornado of 1908. In 2008, on the 100th anniversary of the great storm that changed residents' lives, the Albertville Historical Society displayed photos of the devastation and memorabilia from the storm. A memorial service was held at the First Baptist Church of Albertville.

Historical Society president Dennis Burgess wrote a series of articles for area newspapers about the tragedy. He wrote in the *Gadsden Times*, "Citizens living during this time period, as a result of the storm, were forever changed; some were physically, some spiritually, but to some degree all were mentally."

Chapter 3
MAY 26 AND 27, 1924

Two Days, Two Tornadoes, Two Families Gone

In an isolated cemetery in northern Limestone County, Alabama, a single headstone is inscribed with eight names and the date May 26, 1924.

Beside the marker, a series of small stones continues for twenty feet, marking the length of the grave. Within the single grave are buried the remains of the Collins family of Elkmont, killed when an F3 tornado descended on their farm as they slept.

Ninety miles to the south, in the tiny mining community of Empire in Walker County, a similar grave site can be found. A stone in the New Canaan Baptist Church Cemetery marks the site of the mass grave of eight members of the Robbins family, killed by an F3 tornado that swept through in the dead of night just hours after the Collins family was killed.

Two Alabama families decimated as their neighbors slept, unaware of the carnage.

In 1924, Alabamians had little warning of tornadoes. No televisions, radios or weather sirens announced their arrival. Few rural homes had electricity.

Farmers in rural Alabama knew to watch the skies, especially in spring, for potentially dangerous weather, but at night, when skies turned black, tornadoes approached stealthily, only making themselves known with an ungodly roar and an onslaught of wind, rain and hail when it was too late for anyone to take cover.

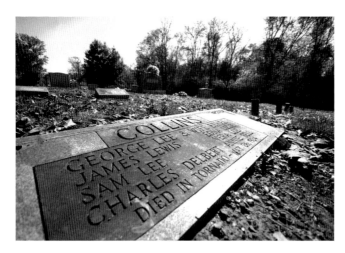

Eight members of the Collins family of Elkmont died on May 26, 1924, when a tornado struck the family farm while its occupants were sleeping. This 20-foot by 7.5-foot grave in Antioch Cemetery is the final resting place for George and Ethel Collins and their six children. *Photograph by Kim Rynders.*

No one could have predicted that two massive tornadoes would drop from the sky, kill two families, as well as three other people in Walker County, and disappear as quickly as they came.

No one could be prepared for the carnage that greeted them on May 27.

1920S: A DEADLY DECADE

Past Alabamians did not take weather events lightly, especially in the spring. The early years of the twentieth century brought dozens of devastating storms. Memories were vivid of the catastrophic 1908 tornado that killed 35 people and injured 188 statewide, with Bergens and Albertville the hardest hit.

On March 21, 1913, twenty-seven people were killed by a twister that struck Clarke and Wilcox Counties, and on May 27, 1917, another twenty-seven were killed by a single tornado that hit Jefferson and Blount Counties. And only four years before the Collins and Robbins families were hit, two outbreaks had proved deadly in Alabama.

On April 20, 1920, the state was hit by three F4 tornadoes during an outbreak in Alabama and Mississippi. The first entered from Mississippi at 8:00 a.m. and traveled through Marion, Franklin, Colbert and Lawrence Counties, killing 44 and injuring 400. A second twister hit rural Winston County at 10:00 a.m., leaving 21 dead and 50 injured across Walker, Fayette, Winston, Cullman and Morgan Counties. A third storm hit Madison County at about 12:30 p.m., killing 27 in Gurley and Brownsboro and injuring 100 more.

Estimates of the dead that day—taken largely from newspaper accounts because there was no National Weather Service at the time and because the existing weather bureau did not consistently conduct storm surveys—are between eighty-two and eighty-eight statewide, with an even greater number of fatalities in Mississippi.

But 1920 had already proved to be a deadly year: On March 28, 1920, nineteen had died when an F4 tornado hit Elmore, Tallapoosa and Chambers Counties during the Palm Sunday Outbreak. This outbreak had an estimated thirty-eight tornadoes that killed 380 in Alabama, Georgia, Indiana, Illinois, Michigan, Missouri, Ohio and Wisconsin.

Less than a month before tornadoes struck the Collins and Robbins families, Alabama had been hit on April 29, 1924, by a series of tornadoes that killed 110 people across the South. The greatest damage was at Anderson, South Carolina. While reports of Alabama fatalities were unconfirmed by the National Weather Service, the Associated Press reported on April 30 that four people died in Opelika when a tornado demolished twelve houses in a poor section of town.

There is no doubt that George Collins in Elkmont and Billy Robbins in Empire knew the harm that Mother Nature could do. There is no doubt that they knew to watch for tornadoes.

The problem was that they couldn't see them coming at night.

THE COLLINS FAMILY

Just two days after the summer season officially got underway with a dance at the resort at Elkmont Springs, the members of the Collins family were beginning a new week tending their farm three miles outside Elkmont, a tiny burg that even now has fewer than five hundred residents.

Schools held their graduation ceremonies the week before, and a long stretch of summer vacation awaited the children of George and Ethel Collins: James Lewis, twenty-one; Sam Lee, nineteen; Charles Delbert, seventeen; Edna Lizzie, fourteen; Vera Lue, twelve; and Annie Bell, six.

George Collins was known as a man who helped those in the community in times of need. If a neighbor was sick, George could be counted on to help him bring in his crops.

He also was a man who lived by the Bible and worked hard to provide for his growing family. The Collinses had purchased the farm only a few years previously and had nearly finished payments.

On May 25, the two oldest Collins boys, Louis and Sam, traveled the ten miles south to downtown Athens, the county seat, to purchase items for the farm. George had finished cutting a tree into firewood and loaded it into a wagon to take to town the next day to sell.

George and Ethel were close with George's nephew James Collins and James's wife, Julia, who lived within sight of the elder Collinses' farm. James and Julia could look out and know that their family was available if needed.

George, Ethel, their children and James and Julia went to bed that night with the farm work done, ready to begin a new day of chores the next morning.

They had no indication that they needed to fear the weather.

At about 11:30 p.m., a storm broke over Elkmont. Some in the community heard the roar as strong winds passed overhead. Others slept soundly on. None would realize for many hours that a killer had been among them.

As dawn drew sunlight over the farms, James and Julia awoke to begin their chores. It was then that the couple and their neighbors were confronted by a terrible sight: George Collins's house was gone.

The main house had vanished with the exception of the steps that once led to the front porch. The family dog lay beneath them, frightened but alive. The wood from the wagon had been tossed like kindling.

It was unthinkable that it could have been a tornado.

No other home or building was touched except those on the Collins farm. No one else had been hurt. Although the Collins barn and outbuildings were destroyed and some chickens had lost their feathers, all of the livestock survived.

Weather experts, though, later confirmed that the deadly winds of an F3 tornado had cut a path through a nearby forest and lifted the Collins home from its foundation. Remains of the home were scattered across the three-acre farm. But where were its occupants?

Neighbors spread the word, and soon a search was underway for members of the Collins family. Their bodies, too, were scattered, left crushed and battered by the winds, all eight stripped of any clothing.

One by one, the bodies of the Collinses were gathered from around the property—some many yards from the house—reverently dressed in clothing donated by neighbors and placed inside a small building known as Hillbilly School until enough hearses could be found to transport them.

Several hearses and two Holland and Company trucks were dispatched Tuesday afternoon from Athens carrying two black caskets, one each for George and Ethel, two gray ones for Louis and Sam and four white ones for the youngest children.

By Wednesday morning, Holland and Company found enough hearses to transport the eight caskets to Antioch Cemetery on what is now Alabama Highway 127 to be buried in the 20- by 7.5-foot grave. The service was held at 2:00 p.m. on Wednesday.

The day after the funeral, Limestone County's two weekly newspapers proclaimed the event one of the most tragic in the county's history.

In the *Limestone Democrat*, beneath the headline "George Collins, Wife and Six Children Killed by Tornado," was written: "Probably the most terrible tragedy ever enacted in Limestone's long history took place shortly before midnight Monday."

A reporter for the *Alabama Courier* wrote, "Limestone has witnessed many sad spectacles but nothing quite as distressing as this has ever happened here before."

THE ROBBINS FAMILY

Itra Robbins knew that the gown being sewn by her older sister Hester would make her May 27, 1924 wedding day perfect. The big event was to be that weekend. Her brother Willie was engaged, too, and planned to be married to the preacher's daughter, but Itra's ceremony came first.

Itra, her siblings and her parents, William "Billy" and Mollie, were looking forward to the pending nuptials at New Canaan Baptist Church in Empire, a church Billy Robbins helped found in 1920.

But Itra's fiancé, Rile Coffman, would never see his bride walk down the aisle in her special dress. Instead, she was buried in it.

Billy, Mollie and six of their eleven children—Willie, age twenty-five; Itra, twenty-one; Virgil, eighteen; Edna, sixteen; Nora, thirteen; and Alta, nine—died on May 27 when an F3 tornado struck the family's home at about 2:00 a.m.

Four older sisters—Hester, Icey, Curtis and Ethel—were married and living in their own homes at the time the tornado struck. Itra's younger brother Clifford, eleven, was spending the night with Hester and was spared.

Billy, like most of the men in Empire, worked in the mines for DeBardeleben Coal Company, but he and Mollie also farmed. The children were expected to help with chores around the house and the farm, and with no television or radio, the family got its fellowship and entertainment at church.

Billy was respected as a hard worker and a leader in New Canaan Church. Mollie was known as a caring mother with a pleasant disposition. She often

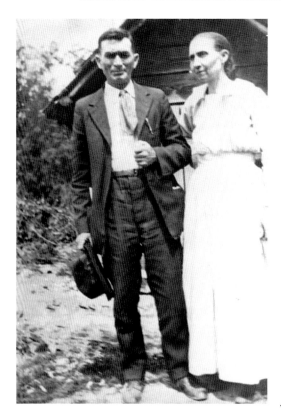

Billy and Mollie Robbins, shown here, were killed in Empire on May 27, 1924, along with six of their eleven children. *Courtesy of Johnie Parker.*

could be heard singing, even on the cloudiest of days, while hanging the laundry or going about her chores. She also had a reputation for making the town's best rice pudding.

Having four daughters out of the home, and with two more children about to marry, the couple would soon have only four children at home. Billy and Mollie also were expecting another grandchild, as Curtis was pregnant.

Attuned to the weather as most farmers were, Billy noticed some clouds on the eve of May 26. He didn't like the look of them. Talking with his neighbors Mattie and Gertrude Owens as they worked in the garden, Billy said, "It looks like we might have a bad night."

He sent young Clifford to his big sister Hester's house to tell Itra and Edna, who had gone to help Hester with the wedding dress, to come home since a storm was brewing. Clifford sent the girls home, but he had been granted permission to stay and spend the night with Hester.

The remaining Robbinses gathered home for the night—all but Willie, who was working the night shift in the DeBardeleben mine.

After the evening Bible reading, Billy, Molly and the children went to bed. Willie, who had gone to sleep on a cot at the coal company, had been awakened about midnight by a supervisor and told to go home—a nasty storm was likely to hit. He would be safer on the farm, the supervisor said. Willie obeyed.

At about 2:00 a.m., fierce winds struck Empire, rattling homes and outbuildings. For a few minutes, families who had awakened clutched one another as the winds howled around them. When it was quiet, the residents stepped outside to survey the damage.

The tornado had swept along a path about a quarter of a mile wide through the town. Trees were uprooted and barns and outbuildings demolished.

The community soon learned that eleven local people had been killed, including eight members of the Robbins family. Two people died in the nearby community of Harmony, where Mrs. Charles Abbot and her daughter, Vera, were crushed when their home collapsed.

In Empire, searchers quickly realized that their neighbors had been hit. With only carbide lanterns to guide them, Doris Estes and Johnny Reeves came to the Hayes home first, which was located near the Robbinses'. Three of John and Carrie Hayes's four children still lived at home, and Doris Estes and Johnny Reeves hoped to find them alive.

They came first upon Carrie, who had been killed by a blow to the head. John was injured but alive. The two older girls had taken shelter in their father's Model T—one of the first in the county—and little Reba, only five, was found tangled in a bedspring. The girls survived.

By the time the search party reached the Robbins home, it had been joined by J.C. Roe, principal of Empire School; Sheriff Jim Daly; Oscar Owens; and J. Ramsey McGowan, cashier at DeBardeleben Company. They brought mules and wagons and gathered stretchers from the mining office. The surviving Robbins siblings rushed from their homes to join the search.

Billy and his beloved Mollie were the first to be found, lying side by side.

Itra's body was discovered by her fiancé, Rile. Her nightclothes had been torn from her body, and Rile, distressed at nature's final insult, covered his fiancée's body with his jacket and gently carried her to the home of Ethel and Ott Carey, where the dead were laid on quilts.

Although most people in the mining community were not wealthy, Billy had managed to save and take out a $1,700 life insurance policy.

The four older sisters agreed that it would be put aside for young Clifford, who was raised by his sisters and who never quite reconciled his guilt over sending Itra and Edna home and into the path of the storm.

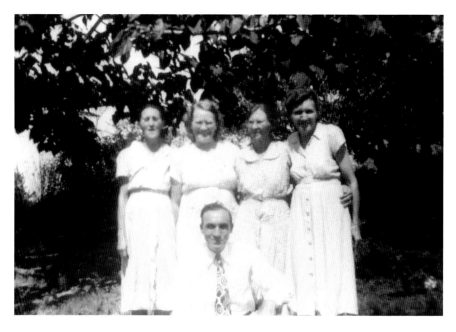

Years after the 1924 tornado killed their parents and six siblings, the surviving Robbins siblings posed for this photo. Standing are sisters Hester, Icey, Curtis and Ethel. Kneeling is Clifford Robbins. *Courtesy of Johnie Parker.*

The eight Robbinses were dressed for burial and laid to rest in one large grave in New Canaan Cemetery.

LEGACY

Stories of these double tragedies have been passed to surviving generations through family lore and newspaper accounts.

Johnie Parker of Birmingham, Curtis Robbins's daughter, wrote the story of the tornado for future generations. Her son, Wade, owns his great-grandfather Billy Robbins's pocket watch, which was found lodged in the trunk of a tree, its hands and crystal missing, fob still attached.

It remains in the same condition as the day it was found.

Descendants of the Collins family of Elkmont decided in the 1960s that a headstone was needed to replace the long-rotted wooden cross on the mass grave in Antioch Cemetery. With donations from family and the community, it was installed, a silent testament to the deadly whims of tornadoes.

Chapter 4
1932 DEEP SOUTH OUTBREAK

A Family Torn Apart

Analiese Schell cries as she recalls her grandfather, Jackson "Lewis" Latham Jr.

His is a sad story, a tragic one, but Analiese weeps not from regrets over his experiences but from sorrow for the family who will miss a man who overcame the tragedy and became a pillar of strength in their lives.

"He didn't dwell a lot," said Analiese. "He wanted to look toward the future."

Lewis died on February 14, 2009, at age seventy-one.

"We knew when he died he was going home to a big family reunion," Analiese said. "That was the way we coped with it."

It was a reunion nearly sixty-seven years in the making—a reunion Lewis had longed for since March 21, 1932, when a tornado swept through Stanton, Alabama, killing his parents and five of his siblings and leaving the four remaining children orphaned.

Many lives were changed that day, when more than twenty tornadoes (reports of the number vary) killed 334 people across the South, including 268 in Alabama. As many as 3,000 were injured. It remains Alabama's deadliest tornado outbreak.

For Lewis, that day began a journey that would either break him or make him stronger.

On March 21, 1932, the family of Jackson Lewis "Jack" Latham Sr. and Maggie Latham was faring better than many of their neighbors during the

Great Depression. Jack and Maggie had nine children: Woodard was born in 1909, Velma in 1910, Lela in 1912, Bertha in 1918, Louise in 1921, L.J. in 1922, Katie Ellen in 1925, Lewis in 1927 and Elvin in 1929.

Although Jack's clothing consisted of patched overalls, faded shirts and shoes resoled with the inner tube from a car tire, his family never complained about a lack of material items.

The family sharecropped and grew enough food to last through the winter. But spring was planting time. The soil had to be plowed, in addition to regular chores such as milking the cows.

Though the family worked hard, they took enough time in the evenings to meet in the family room and share stories from their day. Jack, whom the children called Papa, read from the Bible and reminded the children why it was important to follow its word.

Sometimes, Velma played popular music of the day on the piano and Lela danced the Charleston—but only when Papa was gone. He didn't believe in having any music other than hymns played in his home.

The farmhouse, which had a detached kitchen to protect from fires, was situated in Stanton, Alabama, a small burg located in Chilton County almost in the center of the state. In 1930, the county's population was 24,579.

People did not have telephones or televisions, and news was gathered from newspapers in Selma or other larger towns and by word of mouth. Weather forecasters had few options for warning residents of pending severe storms.

Monday, March 21, was one of those spring days when the weather seemed unable to make up its mind. It began with a heavy rain but gave way to sunshine and warm temperatures, Lewis recalled. The pattern continued, with the temperature dropping and clouds forming before the sun peeked out again.

Other than the weather, it was a typical school day, and when the Latham children still of school age arrived home, they began the chores that would occupy them until dinner.

Following another of the excellent meals for which Maggie was known, the family gathered, as it always did, to listen as Papa read from the Bible. It was a typical evening.

No one had any reason to suspect that danger lurked just outside their cozy home. But at about 6:30 p.m., Papa interrupted his reading when he heard a loud roaring sound approaching the house.

As Lewis recalled, Papa walked to the front door, opened it and uttered his last words: "My God. It's a cyclone!"

What happened next was chaos. The small house shook, and witnesses said it rose fifty feet in the air and exploded. The people inside it were scattered.

In a self-published memoir from 2005, Lewis wrote:

Papa was found near a gristmill...some distance from where the house had been. He was dead when found. Vonnard was found and when asked how he was, he replied "Go find Mama. I'm all right." Bertha was found close to Vonnard and Elvin was found near the road in front of the house, bleeding and crying. Mama was found in the soft fresh plowed earth, buried up to her neck in the soft soil. Every bone in her body had been crushed, and barbed wire was tangled in her hair. She, too, was dead. Bertha and Vonnard were put in the back seat of a car and driven to the nearest doctor's office in Plantersville and put on the porch. Bertha had died by this time, and Vonnard asked for a drink of water. He took a sip, and then he died. The rest of the children, except Velma, were found close to Mama. An ambulance arrived from Selma, about twenty-seven miles distance from us, and the four youngest siblings were put in the ambulance at one time and taken to the Vaughn Memorial Hospital in Selma. In the meantime, Millard Reynolds had decided to walk back in the direction from which the twister had come and after crossing a creek found Velma. All she had on was the cuff of the sleeve of the dress she had been wearing, and she was dead. Millard took off his raincoat and covered her. Then he took her back to where the house had been.

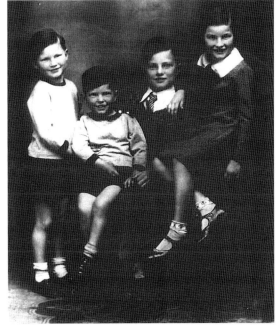

The Latham children orphaned by the 1932 tornado were Jackson "Lewis" Jr., Elvin, L.J. and Katie Ellen. The March 21 storm killed their parents Jackson Lewis "Jack" Latham Sr. and Maggie Latham and siblings Woodard, Velma, Lela, Bertha and Louise. *Courtesy of Analiese Schell/Latham family collection.*

Only Lewis (age four), L.J. (age nine), Katie (age seven) and Elvin (age two) survived, but it would be days before the children realized that the remainder of their family was gone.

At the hospital, the children's injuries were catalogued. Katie fared best with only a bump on the head, L.J. suffered a fractured skull, Elvin had abdominal injuries and Lewis's chest was crushed and his stomach penetrated by slivers of wood and debris. He remembers overhearing a doctor say that another grave should be dug alongside his family—that he would not survive surgery.

But he did.

"THERE WILL BE GREAT SUFFERING"

The Latham orphans, as they had become collectively known, lay in a Selma hospital as Alabamians from across central and northern Alabama began assessing the damage. People were rattled by the unimaginable number of storms and the damage left in their wake.

Governor B.M. Miller issued a proclamation that called on Alabamians to help those in distress. Then he began a tour of the damaged counties in an effort to encourage those who had lost loved ones, been injured or lost their homes and businesses.

Two days after the tornadoes, the *New York Times* reported that Miller was appealing for contributions to be made to the American Red Cross to aid storm victims: "There will be great suffering unless they are aided properly."

The night of the storm, doctors and nurses from Montgomery and Birmingham volunteered their time and worked by lantern and flashlight to aid the injured.

At least twenty-five cities in eleven counties reported one or more deaths: Stanton, Decatur, Marion, Demopolis, Union Grove, Linden, Plantersville, Sycamore, Thorsby, Northport, Huntsville, Scottsboro, Paint Rock, Collins Chapel, Columbiana, Faunsdale, Bethel Church, Jemison, Falkville, Sylacauga, Bridgeport, Lineville, Gantt's Quarry, Cullman and Corinth.

In Columbiana, eleven-year-old Ray Atchison had gone next door to the home of his aunt and uncle, Bonnie and Will Atchison, who lived on Main Street. Aunt Bonnie was home, and several cousins and neighborhood children were playing in the house, recalled Ray in January 2010. By that time, Ray was eighty-nine and a retired professor from Samford University, but the memories of the tornado remained vivid.

"My aunt heard a dog barking on the back steps and went to see what was wrong," Ray said. "She saw the storm coming and gathered us in the middle room of the house. The windows started crashing all around us, and [tree] limbs were going through the roof above us. We saw the tornado coming. You could look up and see a big, dark cloud. Glass was breaking all around us. It was a terrible noise."

Over the roar, Ray, his aunt and the other children began to pray aloud. When the winds stilled, everyone in the home was safe. Quickly, Ray and the others went next door to the home in which he lived with his parents, Edward Walter and Jessie Atchison.

A tree limb had gone through the roof of that home, as well, but Ray's mother and sister were unharmed. "My mother was so happy to discover I was okay," Ray said. The family barn, however, was gone. "We had a chicken yard and a cow barn. The barn lifted off the old cow, and she didn't have a single scratch."

Ray's father had been doing some work in a shed at the nearby planing mill he owned. "He worked not far from the house," Ray recalled. "He looked up and saw the tornado coming. He knew he couldn't stay in the tin shed, so he climbed up in a boxcar." The shed was demolished, but Ray's father survived inside the boxcar. Ray did suffer a loss that day, though: his pony was killed by a piece of timber. "She was a beautiful, beautiful pony," he said. "That made me cry."

Ray remembers the chaos that followed the storm. Ambulances filled the streets of Columbiana, trying to get to the injured to take them to Birmingham hospitals. The Shelby County Courthouse became a makeshift hospital.

Columbiana and Stanton weren't the only traumatized towns that day. One estimate stated that seven thousand homes and businesses were destroyed statewide.

Weather experts faced a daunting task but eventually determined that the tornadoes began near the Mississippi and Alabama border when warm air from the Gulf of Mexico collided with a cold front to the north.

Most weather experts agree that the first tornado hit near Demopolis followed by another near Linden and Faunsdale.

Northport was one of the most badly damaged towns: 38 people were killed and 250 were injured. Northport was so decimated that the National Guard was called and the town was closed to outsiders. "It looked as if Northport had been bombed," the *Tuscaloosa News* reported at the time.

A group of students from the University of Alabama, located in Tuscaloosa, were credited with helping to search for Northport victims. The

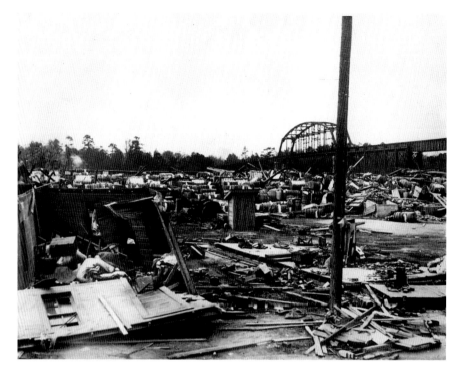

At least 38 people were killed and 250 were injured in Northport during the March 21, 1932 Deep South Outbreak. *Courtesy of Alabama Department of Archives and History.*

New York Times reported that the students did "heroic work in ministering to the injured."

Chilton County, where the Lathams' hometown of Stanton is located, reported 58 people killed. The Union Grove community near Jemison was particularly hard hit. In Marengo County, 36 were reported dead, 136 were injured and 180 homes were destroyed.

In Demopolis, twenty-nine people were reported dead; in Sylacauga, one hundred homes were destroyed and nineteen people killed.

In northern Alabama, tornadoes went in two directions.

At 4:30 p.m., a tornado that modern scientists would rank an F4 began its devastating path four miles south of Cullman and continued through tiny rural communities of Phelan, Bolti, Berlin and Fairview to Arab.

Destruction occurred in Marshall, Morgan and Cullman Counties, but the reported deaths all occurred in Cullman County: 18 died, many inside a box factory outside Berlin, and 100 were injured; 6 people inside one Cullman home were killed, and a teacher in Fairview died while still at school.

As part of a second wave of storms, another F4 began its path at 8:00 p.m. in Lacey's Spring and continued into Tennessee, leaving 38 dead and 500 injured. Weather experts believe that this wave could have contained two or three tornadoes that struck Morgan, Madison and Jackson Counties before heading into Tennessee. Recorded deaths included an elderly couple in Lacey's Spring, 4 people in Paint Rock—3 of whom died when a hosiery mill collapsed—and 32 in Jackson County, where 125 homes were destroyed in the rural communities of Boulevar, Kyle Springs, Carnes, Tupelo, Boxes Coves, Maynard's Cove, Washington Cove and the Ridges.

In Clay County, 12 people were killed and 200 injured by a tornado that was four hundred yards wide and remained on the ground for thirty miles.

The tornado outbreak was so severe that newspapers across the country reported its devastation. It was so deadly and costly that it was named the Deep South Outbreak.

When the storms were over, thirty-three tornadoes had struck in southern states from Texas to South Carolina on March 21, continuing until about 1:00 a.m. on March 22, according to the National Oceanic and Atmospheric Administration.

Currently, the National Oceanic and Atmospheric Administration ranks the Deep South Outbreak as number eight on its list of "Famous Large Tornado Outbreaks in the U.S." and estimates that damage was $5 million in 1932 dollars.

"IT WAS LIKE A GREAT BIG TRAIN"

The country had fallen in love with the Latham orphans, whose story was recounted and updated by dozens of newspapers. Within days of the storm, the *Selma Times-Journal* wrote about seven-year-old Katie Ellen Latham:

> *If she thinks of her parents, Mr. and Mrs. Jack Latham, or of the five older sister[s] and brother[s] who lost their lives the past Monday she does not speak of it, but her serious brown eyes are brooding at times, and are more speculative than indifferent.*
>
> *She was in the house with her mother, near the open fireplace about which the big family gathered for their happiest hours, when the storm roared over their home. In a halting little voice she talked of that sound which spelled doom to her family.*
>
> *"It was like a great big train, but it was louder," she explained. It hit the house and Katie was whirled out of doors, "before I knew it," she*

explained. The next impression which her little mind picked up was of her mother's still body nearby, and one of the smaller children within a short distance, and Mr. Rush, a neighbor, coming to them over the newly ploughed field which engulfed them all in mud.

Within days of the terrible tragedy, the *Selma Times-Journal* published a story that brought smiles to the faces of everyone who had heard of the Latham orphans' plight: The four children were to be adopted by a doctor and his wife.

Everyone, even the nurses who had come to love the children and treated them as their own, was happy about the outcome. The little Lathams left the hospital for a good and loving home.

The Selma paper reported:

Their young hearts filled with joy, four happy Latham children went Monday to their new home from Vaughan Memorial Hospital where they have been the center of interest since the disastrous tornado of March 21 which swept away their home near Plantersville killing their parents and five older brothers and sisters. The four…have turned to their newfound protectors with affection and trust.

But there is a story behind the headlines.

In his memoir, Lewis Latham recounted the disturbing details of his life with the couple who adopted him and his siblings. The couple was abusive and, worse, worked to alienate the children from one another. Unable to bear it, Lewis ran away on several occasions before finally being placed in the foster care system.

"It looked like they rallied together and adopted these kids, but it really wasn't like that at all," Analiese Schell said. "My grandfather said, 'I wrote this book because I wanted to shed light on the foster system back then.' He wanted somebody to do something about the foster system. He wanted somebody to know the truth."

Lewis eventually joined the U.S. Army and raised a family of his own. As he grew older, he was determined to reconnect with his surviving siblings and find the graves of the ones who had died.

Lewis found the seven members of his family killed on March 21, 1932, buried in a Stanton cemetery beneath a single headstone. Four stones marked places left for the surviving children to be buried upon their deaths. But it was his children and grandchildren he focused on later in life, Analiese said.

In 2005, Lewis Latham wrote a memoir about the impact of the 1932 tornado that killed his parents and siblings. It was called *My God! It's A Cyclone! A Survivor's Perspective on the Long Term Effect of Nature's Fury*. *Courtesy of Analiese Schell.*

"He told me and my sister about the tornadoes and the family, but he always focused on the positive," she said.

As an adult, Lewis wrote this ending to a poem about the tornadoes:

> *Mama and Papa are gone and five siblings as well,*
> *The search for happiness without them has failed*
> *They rest in their graves near a little country church.*
> *I can only hope that in Heaven, I see them first.*
>
> *To greet them with the longing I've had since a boy.*
> *And re-unite with this handsome boy and his girl*
> *And renew the love and happiness and joy,*
> *Of this long ago, far away world.*

Analiese has no doubt his wish came true. "It breaks my heart he never found the happiness he wanted here on earth, but he never gave in to the pain," she said.

Chapter 5
1974 SUPER OUTBREAK

"Black Wednesday"

BY THE NUMBERS
148 tornadoes
13 states
315 dead total
87 dead in Alabama
$600 million in damage

The family of Reverend Ananias Green huddled together on the sofa in their living room, awaiting the onslaught. Ananias held baby Titus and Ananias Jr. sat nearby. Ten-year-old Amos, who adored his father and trailed him like a shadow, was afraid of the approaching storm. Sitting between his mother and father, he trembled. The winds were growing louder.

As the roar became unbearable, the sofa was lifted. Ananias could see pieces of drywall moving in front of his eyes as he rose into the air—the very walls that made up the shelter that was supposed to protect his family.

Suddenly something struck the young pastor's back, hard. His next memory was of lying in the mud of Isom's Orchard, unable to move and not knowing what happened to his wife and three sons.

When Ananias's battered body was finally discovered, his family already had been found, scattered and broken across the family's yard and the orchard.

It would be days before the dead were counted and the damage tallied from the strongest tornado to ever hit Limestone County, Alabama—on April 3, 1974.

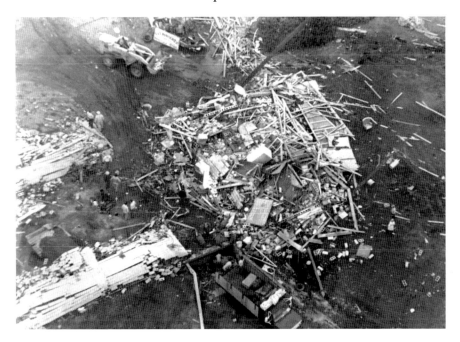

An aerial view of a home shows the devastation wrought in Tanner on April 3, 1974.
Courtesy of Limestone County Emergency Management Agency.

In the final tally, Reverend Green's losses were staggering: his wife and little Amos were gone.

Type the words "1974 Super Outbreak" into the search engine of a computer, and a list of dozens of websites appears. Despite some varying statistics on these sites, two numbers remain consistent: 148 tornadoes and thirteen states.

Death tolls across the states—with Xenia, Ohio, being hardest hit—vary from 315 to 350, with as many as 6,000 injured and hundreds of homes demolished.

Six storms that day were classified as rare F5s—the most deadly in intensity. Two of the F5s ravaged Alabama in one day.

As with any tornadic incident, this one was caused by a clash of weather systems—cold, dry air from the north and warm, moist air from the Gulf of Mexico. The reason this particular collision of warring systems created the most tornadoes ever spawned in one event is still a mystery.

What is known is that the first of the twisters touched down at about 2:00 p.m. in Bradley County in south central Tennessee and Gilmer County in

northwestern Georgia. A few minutes later, tornadoes were spawned 450 miles away in central Illinois; then, within minutes, more storms hit Indiana. For fifteen hours, winds raged from as far south as Laurel, Mississippi, to Detroit, Michigan, and to Staunton, Virginia, in the east. They wreaked havoc in Illinois, Indiana, Michigan, Ohio, Kentucky, Tennessee, Alabama, Mississippi, Georgia, North Carolina, Virginia, West Virginia and New York.

When the tornadoes finally stopped, the 148 twisters had covered 2,014 miles, with one that struck Guin in Marion County, Alabama, staying on the ground for an astounding 100 miles.

"A NIGHT OF FEAR AND LOSS"

According to the National Weather Service in Huntsville, the activity in Alabama began at about 4:30 p.m. when a tornado touched down in Concord, eight miles west of Birmingham, causing damage but no deaths. Another followed, causing slight damage in Calhoun County, and a third injured twenty people in Cherokee County.

The worst of the storms began at 6:30 p.m. when a tornado formed over Newburg in Franklin County and traveled eighty-five miles into Tennessee, hitting rural Lawrence County, Tanner in Limestone County and Harvest and Hazel Green in Madison County.

Rapidly intensifying to an F5, the funnel swept away home after home, causing fourteen deaths in Lawrence County. Six members of one family and four members of another were killed near Moulton. Their homes were swept from their foundations.

The funnel crossed Wheeler Lake as a giant waterspout and entered Limestone County at 7:05 p.m., demolishing mobile home parks and subdivisions in Tanner. It struck in the community of East Limestone and then moved into northwestern Madison County, where it devastated Harvest.

When it was over, five people were dead in Limestone and nine in Madison County. Before emergency workers could remove the victims to hospitals, another storm approached this area, prepared to follow nearly the same path.

It hit at 7:35 p.m., killing eleven more in Limestone County and five more in Madison County. This F4 had nearly the exact point of entry near the Tennessee River. Along its twenty-mile path, its course varied from that of the first tornado by a block to less than two miles. The arrival of a second devastating twister hindered rescue efforts.

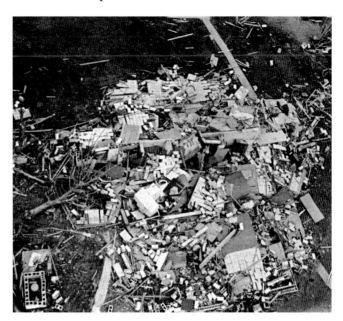

Homes in Tanner were reduced to rubble. *Courtesy of Larry Waldrup/ Waldrup Photography, Huntsville.*

Farther south, at 7:00 p.m., an F4 tornado bore down on Pickens County near Aliceville and stayed on the ground for an hour before hitting Jasper in Walker County. It then skipped northeastward into Cullman County before dissipating; 2 people died in a church in Walker County, 1 died in Cullman and 178 were injured. Still, the deadliest was to come.

At 8:50 p.m., an F5 touched down six miles north of Vernon in Lamar County before hitting Guin in Marion County and Delmar in Winston County. This tornado killed thirty-one people, including twenty-three in Guin. And it still wasn't over.

An F3 tornado formed southeast of Decatur at 10:50 p.m. and moved toward south Huntsville, hitting the Army Missile and Munitions Center and School on Redstone Arsenal, where one thousand troops were housed. The barracks and gym were among the ninety-eight buildings damaged or destroyed. Nearby McDonnell Elementary School was also devastated.

This massive twister leveled homes in Glen'll Trailer Park and destroyed dozens of businesses in Parkway City Mall on South Memorial Parkway.

At about 11:00 p.m., it crossed Monte Sano Mountain, elevation 1,640 feet. It dissipated over Jackson County, and the deadly night had reached an end.

The word from Marion County was that "Guin was wiped off the map." Madison and Limestone Counties, which had been hit with what

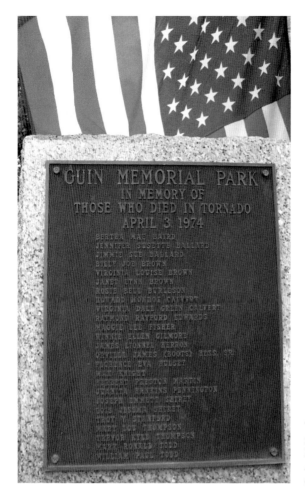

The town of Guin erected a marker in memory of those killed in the devastating F5 on April 3, 1974. *Courtesy of City of Guin.*

seemed an unending wave of storms, were in ruins. The rescue and recovery soon began.

Within days, the *Huntsville News* published an editorial on these efforts in Madison County, which was the home of high-tech industries, as well as Redstone Arsenal and NASA's Marshall Space Flight Center. Here is a partial excerpt:

> *It is quite a plunge from federal plum area to federal disaster area but Huntsville took the dive during seven frightening hours late Wednesday and early Thursday as the tornadoes marched like soldiers on parade, back and forth across Madison County. It was during those hours, however, and the*

hours immediately following, that the residents of the city and county proved their mettle... They came forward by the hundreds to help.

No one compelled them.

But they were desperately needed. And they were there.

If, in some respects, it was Huntsville's darkest hour, it was also her finest. The stories that move us most are not the headline grabbers but the little incidents. The injured man in the emergency room trying to allay panic among less seriously hurt as the lights go out. The governor in his wheelchair who, brought face to face by his own efforts with victims of the storm, weeps for their misery and desperation. The stolid businessman in mud to his knees sifting though the wreckage to try and find a victim before time runs out.

Children who carried with them into the tubs kittens and puppies, forgetting their own fears as they try to calm the young animals.

The mother who stayed up all night preparing hot food and drinks for storm victims.

The deputies and policemen who, their shifts over, refused to leave until the last victim had been found.

The men and women who volunteered their personal vehicles to transport the injured and dying.

The list is endless. It was a night and day of countless small heroisms.

It was a night of fear and loss, it was also a night of extraordinary compassion. Love was evidence in its most selfless form, almost embarrassing in its naked display of basic human emotion.

Alabama governor George Wallace, wheelchair-bound after a 1972 assassination attempt, visits Limestone County to view the impact of the two tornadoes that struck the county on April 3, 1974. *Courtesy of Larry Waldrup/Waldrup Photography, Huntsville.*

Governor George Wallace, wheelchair-bound since an assassination attempt in 1972 when he was running for president, toured the devastated areas the next day, witnessing firsthand the destruction. He declared the sixteen devastated counties to be disaster areas.

Another celebrity visitor was the physicist Dr. Theodore Fujita, who developed the tornado ranking system known as the Fujita scale. Because the outbreak had spawned an unprecedented six F5s, including the two in Alabama and the one that leveled Xenia, Ohio, and twenty-four F4 tornadoes, Fujita conducted the most in-depth storm survey ever undertaken. What he learned would later help save lives.

According to Birmingham weather expert J.B. Elliott, the outbreak also marked the first time that Dr. Fujita considered assigning an F6 ranking for a tornado—the one that struck Guin. The only other time he considered assigning an F6 ranking was for another tornado that hit Alabama, the Smithfield Tornado of 1977, Elliott said. Historians say that Fujita considered an F6, which would have winds from 319 to 379 miles per hour, to be an "inconceivable event." Both the Guin and Smithfield tornadoes eventually received F5 rankings.

The research from the outbreak led the National Oceanic Atmospheric Administration to add new technology to increase warning times and expand its network of weather radios. Most of the communities hit installed their first warning sirens or added to existing ones. The town of Guin subsequently formed its first rescue squad, with thirty-one trained staffers. But it was too late for the people of Alabama that night.

Northeast Alabama hospitals were scenes of chaos as they quickly filled and attendants sent the injured away. Huntsville Hospital, Decatur General Hospital, Parkway Medical Center, D.E. Jackson Memorial Hospital in Lester and Athens-Limestone Hospital were overwhelmed with constant streams of arrivals. Ambulances and makeshift ambulances often were turned away, leaving the injured to seek help elsewhere.

"THE HOUSE EXPLODED"

A smile plays at the corners of the Reverend Ananias Green's lips when he thinks now of sitting on the Tennessee River in the twelve-foot aluminum boat with his son Amos—sun shining, fishing poles dangling and comfortable silence unfolding.

That was the way Ananias wanted to remember ten-year-old Amos. When other thoughts tried to creep in, the bad ones, the pastor firmly shut an imaginary door in his mind.

Then Ananias decided it was time to tell his story—to extract the memories of the night in 1974 when one of three tornadoes that struck Limestone County sucked the five members of the Green family from their homes, killing the pastor's wife, Lillian, and fatally wounding Amos, who died days later.

"I would like for it to die out of my mind," Ananias says, even now.

His surviving sons, Titus and Ananias Jr., were seriously injured, and Ananias himself was left for dead in Isom's Orchard amid the debris from what once was his home.

"I felt like some things were tender," he said. He made a motion encompassing his head. "I wanted to leave the tenderness where it was. I can talk about it now." The words required in the telling, though, are hard ones, tragic ones—the kind that will bring even strangers to tears. But the pastor hopes that something positive will result.

"I'd like people to be aware of what can happen," he said. "Don't take anything for granted. Be aware and go to shelter. If one life is saved, that will mean everything to me."

These days, Ananias Green, retired from Laborers' International Union of North America, spends quiet weekdays with his wife, Sarah, and Sundays leading his flock at Macedonia Primitive Baptist Church in Limestone County.

His sons who survived the tornado on April 3, Titus and Ananias Jr., are successful adults.

However, he can't forget Amos—the little boy who was his shadow and who joined him on Wednesday afternoon fishing trips—nor his first wife, Lillian, who was the perfect pastor's wife, caring for the children and ensuring that her husband was practiced and looking his best come Sundays.

"We were sitting on the couch, and Amos, he's scared—he's sitting between his mama and daddy," Green said. "Titus, the baby, he was sitting on my lap. The house, it was just like it kind of exploded."

Green recalled being lifted into the air, seeing pieces of drywall flying past and then being struck in the back with what he thinks was a two-by-four.

"It happened so fast," he said. And, yes, the wind did sound like a freight train roaring past.

Rescuers found the boys and transported them to various hospitals, whichever ones had space. Lillian was also discovered in the orchard but died before she could receive treatment.

Ananias, though, was left undiscovered in the orchard. It was Joe Isom, the orchard owner from whom the Greens rented their home, who found him.

Green spent three months in the now defunct Jackson Hospital at Lester, where doctors told him that he would never walk again.

"I said, 'God has not shown that to me. I believe I am,'" Green said. Amos, like his brothers, survived, only to die later after doctors tried to remove a wood splinter from his brain.

"I wasn't able to go make funeral arrangements," Green said. He also was unable to attend the funerals of his wife and son. When he was finally well enough for a visit from the now recovering Titus and Ananias Jr., the Reverend Green wept.

Ananias was accustomed to challenges. Before the tornadoes, when he was made assistant manager of a mixed-race Laborers' Union post, people warned him that he risked violence. "I wanted to prove to the world I could do the job with respect and honesty, no matter what color," he said.

So he wasn't about to let a little thing like a doctor's dire predictions keep him down. When Ananias finally left the hospital, he left walking. He learned to perform the duties once handled by Lillian: cooking, washing clothes and keeping house.

Then he met Sarah, who had daughters of her own, and later Sarah and Ananias had a son together, Delano. The pastor credited the soft-spoken woman with kind eyes with helping him cope.

"I'm very thankful," he said.

This man of such tremendous faith does not question God. "The Lord is just in all his dealings," Ananias said. "He knows what's best. We each have our time, and our days are numbered. Why should I question God?"

Instead, he clings to the image of Amos in that fishing boat.

"I'd rather remember me and him going fishing the last time and the joy that we had," Ananias said.

"THE END OF THE WORLD"

On April 3, eighteen-year-old Faye Evans, now McElyea, was living with her parents and siblings at the family's home on East Limestone Road, a few miles from the Limestone–Madison County line.

Inside, her graduation gown was hanging in preparation for the commencement ceremony on April 14. "We were outside playing softball," she

said. "That's what we did about every day after school." Neighbors were washing cars and windows. "It was just that kind of day. A nice day," she recalled.

The weather was so pleasant, in fact, that Faye was surprised when her father, Homer Evans, suddenly emerged from the home and told his wife, Edith, and any children in the yard to get in the family car.

"We were telling him we didn't want to," Faye said. "I remember him looking back at the sky. He made us get in the car, and we rode up to Fairview Church."

Once in the church parking lot, the family sat in the car for several minutes, not emerging because no one else seemed to be inside. Finally, Homer began the drive home. It quickly became evident that a tornado had struck East Limestone Road.

"People started hollering, 'There's another one coming,' so we headed back to the church," she said. Faye said it was odd that her father ordered them into the car. "People didn't leave their houses for storms, then," she said. "We were among the few people to leave. He saw something that we didn't."

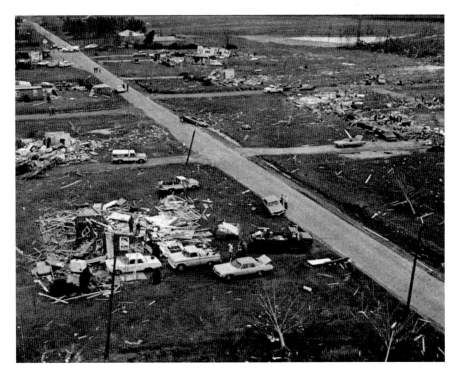

One of the two tornadoes to hit Limestone County on April 3 demolished homes along East Limestone Road. *Courtesy of Larry Waldrup/Waldrup Photography, Huntsville.*

Finally, when the winds subsided, the family went home, walking into the neighborhood because the roads were blocked. It was getting dark, and Faye witnessed the destruction during flashes of lightning.

They passed two houses, three, then six, seven. As many as nine of their neighbors' homes were gone, but when the Evans family reached their home, it was still standing.

The children were lucky they hadn't been in the yard. "The windows were blown out and trees were down but it was still there," she said.

I couldn't see much in the dark, but I could hear people hollering for help and dogs howling. Across the street, we helped move brick and dig kids out who were living with their grandmother. We started loading people in the backs of trucks because people couldn't get out. I remember thinking even at that young age, "This is the end of the world," and it was as we knew it in that time and in that place.

"LIKE IN A HORROR MOVIE"

Mike Kelley of Athens was seventeen years old when he drove into the path of the second tornado to hit Tanner that night. He and his friend Ray Sanders had left baseball practice and stopped to get a hamburger at Wendy's.

Seeing several emergency vehicles pass, Mike grew curious and followed them to Tanner. There the boys saw the devastation caused at Lawson's mobile home park by the first tornado to hit Tanner, an F4.

"The huge pine trees were all broken down like toothpicks, and the trailers were shredded and some even completely missing from their concrete pads," he recalled. "There was a distinct path of havoc straight through the park, with some trailers outside that path being undamaged. I had never before seen anything like that damage."

The boys reached Tanner Crossroads as they headed back toward Athens, unaware of the approach of a second tornado, an F5, which followed nearly the same path.

"As we went past the sheriff's deputies on the roadway, I saw them all pointing southwesterly into the sky and begin to lie down onto the wet, grassy median," he said.

Stronger winds began to rock my 1966 Mustang, and large hail began pounding along with the intense rainfall. An emergency vehicle came

screaming up next to me and turned left, westward, toward Tanner High School. I was so fearful at that time that I turned my car to the left, following the emergency vehicle, and drove into the oncoming hell as the tornado bore down within a quarter of mile to the crossroads. The flashes of lightning were blue and red and green, and the roaring was loud, like a jet engine whining. As I looked out my window toward my left, I could see the swirling twister, wide and flat, illuminated by the constant lightning that served as a backdrop for debris flying in a circle around the huge vortex, like in a horror movie.

Suddenly, the winds stopped. "It was over in a few seconds. I realized that something huge had just happened, but I still had no idea of the magnitude of what we had just witnessed."

Mike drove back toward the crossroads. "What I encountered at the crossroads, just two minutes after turning at the traffic light, was mind-boggling. I almost drove into the intersection because it was a total complete darkness. No lights, no gas stations, no traffic light—nothing. Everything wiped away in a matter of seconds. It was eerie and surreal."

The boys noticed that a large turn-of-the-century Victorian home that had been on the southwest corner of the intersection when they passed previously was no longer there. They could see pinpricks of light as the home's occupants stumbled into the road with a flashlight.

"Suddenly, a family of four came into my headlight beams and wandered slowly up to my car," Mike recalled.

There was a father, mother and a boy and girl, all bloody and dazed. Some of their clothing was ripped and torn, and they had scratches and cuts all across their backs and sides. I was fearful that they were injured so badly I wouldn't know how to help them. Thank God that they simply walked to my car, asked if I would mind giving them a ride to the hospital. I know they were in shock and had no idea how injured they were. I put all four of them in the backseat of that Mustang and I don't know how they all fit. But they needed medical attention and I was all they had.

On the way to Athens-Limestone Hospital, the father told Mike his story:

He told me that they had gone to a shelter when the first tornado had been spotted. Once the first twister had cleared the area, the local weatherman had given the all-clear so they returned home to Tanner. As they walked

into their house and sat down, the second twister was bearing down on them. They all ran into a lower floor bathroom and clung to each other for dear life as the tornado actually sucked the house up and away from them, wreaking havoc on their skin with the flying debris. In a matter of seconds the house was gone and they were in the pouring rain.

Mike left the family outside the hospital entrance, where ambulances from cities across North Alabama had arrived bearing the injured.

"As we were arriving at the hospital's ER, the man was offering to pay me for the ride. He apologized for making a mess in my car and getting blood on my seats," Mike said.

To this day, Mike does not know the identities of the family. "Mother Nature touched many that horrible night and left indelible memories of their exact few seconds in the tornado's path, a few seconds that would change their lives and futures forever. Mine included."

"THEY NEED TO BE REMEMBERED"

Walter McGlocklin lives in a home in Tanner he rebuilt in 1974. It is a duplicate of the one that blew apart on April 3 of that year, toppling a chimney onto his wife, Ruth, who was futilely shielding Walter Jr., age two, and Sandra, age five.

Walter, an Athens Utilities lineman, called from his only son's birthday party to help repair downed power lines from high winds experienced earlier in the day; he returned to the home after two tornadoes struck the area—the first at Lawson's Trailer Park and the second at his home.

When he saw the rubble of his home, he rushed inside and began digging. He could hear cries of a small child, Nancy.

He freed the hysterical three-year-old, but she could not stop screaming. Walter knew that he needed to keep digging, and soon he saw his wife, Walter Jr. and Sandra. They had been crushed to death.

Another daughter, Grace, age seven, was also freed, as was Walter's nephew, Jerry Beckham, fifteen, who was at the home when the tornado hit.

Understandably, Walter does not often speak of that night but sometimes feels the need to remind others they existed. "They need to be remembered. My wife and two children got killed, and I'd like for them to be remembered," he says.

Walter learned to care for his surviving daughters, Nancy and Grace, now grown and married. The storms instilled in him a deep fear and respect for the damage they can do. "I built a storm shed right behind my house," he said. "I go there if it gets rough."

Every few years, when deadly tornadoes strike Alabama, Walter tries to avoid media coverage. "It brings back bad memories," he said.

While clearing his land after the tornado, someone found a damaged photo and gave it to Walter. It was of Walter Jr. It was the only photo found of his family, and Walter keeps it on display.

"LIFE STOPPED AND STARTED OVER"

Marilyn McBay was a young mother when the tornado struck her parents' home, at which she and her husband were staying on April 3, 1974.

She was holding six-day-old Mark, and her mother was holding two-year-old Jason. As the family, seven members in all, were sucked from the home on U.S. Highway 72 East in Limestone County, the children were pulled from the protective arms. It was hours before a dazed Marilyn discovered that her sons were okay.

For her family, the aftermath was a time to give thanks, despite the loss of her parents' home and possessions and her mother's serious injuries that left her in pain for much of the remainder of her life.

"We were all spared," she said. "It's a day to be thankful. You found out how good people are. Everyone was just so wonderful to draw together in the community."

Still, the losses were hard. "My parents lost everything," she said. "It was heartbreaking to see your parents start over. But Mother wasn't a complainer at all. She was in pain a lot, but you wouldn't know it."

Marilyn never dwelled on memories of the day, she said, except perhaps "when April 3 comes around."

"There are so many funny things and tragic things that happen," she said. "It was a joke later on when Mother would look for something, and we'd look at each other and say, 'Was that before the storm or after the storm that we had that?'" Marilyn says. "It was a point where life stopped and started over."

Spencer Black, *right*, who was director of civil defense in Limestone County, works during the 1974 Super Outbreak to warn people and direct rescue efforts. *Courtesy of Limestone County Emergency Management Agency.*

ON THE FRONT LINES

Spencer Black, who was director of Limestone County Civil Defense in 1974, spent the evening of April 3 manning radio transmissions—along with meteorologist H.D. Bagley, broadcast journalist Bill Dunnavant and radio disc jockey and announcer Mike Davis—and warning the people of Limestone County of the impending danger.

The young director, who was still learning his job, manned the single telephone line in the Civil Defense Office that night.

In the aftermath, he was hailed a hero.

Although warning systems and storm forecasting have advanced in the past three decades, these systems don't work if people do not heed the danger, Black said.

"WHEN YOUR TIME COMES, IT COMES"

In 1974, Tom Griffis lived in Huntsville, about one hundred yards from where a tornado devastated Parkway City Mall and destroyed many homes.

"It took out the electrical substation behind the mall, along with many houses and churches between Redstone Arsenal and Whitesburg Drive," Tom said. "I had a front porch in my front yard, but otherwise we were just scared. When the tornado came through my neighborhood, I started shaking so bad that I couldn't strike a match. I would just shake it out!"

The next morning, Tom and his wife drove to Athens to check on his parents:

I had to stop to digest the damage. From Highway 72, about a mile past the Mooresville Road intersection, there was nothing but dirt. We stopped in the middle of the dirt area. For about an eighth of a mile, everything was gone, grass included. Then there was 100 yards or so to either side that contained trees with no bark, then another zone of trees with bark, but no leaves, with lots of damage, then another zone of just damaged trees. This view stretched from southwest to northeast, as far as you could see in either direction. It was very chilling.

At his parents' home, Tom learned that his father's friend, G.W. Feigley, owner of McConnell Funeral Home, had provided ambulance service with his hearses after the first storm.

"He, his crew and a lot of cops were all on Highway 72, trying to help the injured, when the second storm was sighted," Tom said. "Everyone hit the ditches on the sides of the highway, but G.W. just lit a cigarette and said that when your times comes, it comes, and just stood there and watched it go by. He wasn't scratched."

"I LOST THE BOYS"

In Tanner, Sandra Birdwell was home alone with her two sons: Jeff, age seven, and Neal, three. Her husband, Larry, was working 4:00 p.m. to midnight at the Monsanto plant in Decatur, and Sandra was listening to news reports of impending severe weather.

She could feel that something was amiss. The sun was shining, but the sky suddenly began spitting hail and rain. Everything seemed to take on a greenish tint.

"I could tell something was wrong," she recalls. "It was just a weird feeling, just the strangeness of the atmosphere."

Still, she didn't realize that a tornado was near her home until she looked out the window. "I saw it coming across the river," Sandra said. The Birdwell home was situated high enough for her to have a view of the Tennessee River, which divides Morgan and Limestone Counties to the south. "All back in there, it was pitch black."

She thought, because she could see no funnel, that the black cloud was not a tornado. But something compelled her to take cover. "I don't know what made me do it. I never had put the kids in the closet before," she said.

Before taking the boys into the bedroom closet in the middle of the home, Sandra opened as many windows as she could, which, according to wisdom of the day, was supposed to help relieve pressure and keep the winds from demolishing the home. This was one of the myths dispelled following the 1974 outbreak; people are now told to keep windows and doors closed during a tornado.

"Right before the tornado hit, it got deadly quiet. You've never heard anything that quiet," she said. "I remember thinking 'That's what this is.'"

In the closet, Sandra put her body on top of her sons. "I was so scared I was shaking. One of the boys, I can't remember which, said 'Mommy, are you cold?'"

Suddenly, every door in the house slammed shut and the roof of the home collapsed. "Then the tornado came and blew us out," Sandra said. "I lost the boys. I couldn't hold on to them."

As she was struck by flying debris, including a board with heavy construction nails that imbedded into her arm, she recalls thinking that she wanted to lose consciousness but thought that if she did she would die. When the winds stopped, Sandra was lying on the foundation of what was once her home.

Neal was crying, and she could see him nearby, also on the foundation. His scalp was peeled back by the return vent of the air conditioning unit, but he was otherwise unharmed. Sandra could not see Jeff.

The Birdwells' neighbors, whose home also was destroyed, came to check on her and the boys. "I said I couldn't find Jeff, and their teenage son, Tim Sulcer, came running to help," she said. "I'll never forget him for that."

Tim soon located Jeff in the family's vegetable garden a few yards from the home. He, too, was cut and bruised, and he had rocks in his eyes. Suddenly, incredibly, an ambulance appeared to take the family to Athens-Limestone Hospital. When reports of several tornadoes striking first began, emergency personnel had been stationed around the county so that they could quickly reach the injured.

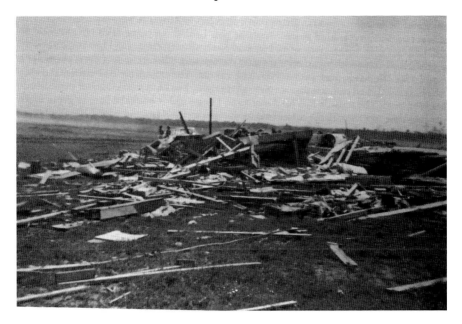

Sandra Birdwell took her two young sons and hid in the closet when the April 3, 1974 tornado approached Tanner. This is what remained of her home afterward. She and the boys were injured but survived. *Courtesy of Sandra Birdwell.*

Sandra's relief was short-lived when the ambulance personnel told her that another tornado was on its way and was expected to take the same path. "The boy putting us in the ambulance was scared to death," Sandra remembers.

She said she knew that the second tornado had also hit near their home because when she was released from the hospital the debris had changed. The foundation of the home had been wiped clean of rubble, and a car she had previously noticed wrapped around a telephone pole was nowhere to be seen.

"If they hadn't gotten us out in time, I don't know what would have happened," she said.

"SOMETHING OUT OF THE OLD TESTAMENT"

Bob Dunnavant, a reporter for the *Huntsville Times* in 1974, survived the tornado by taking cover in a ditch in Tanner.

A quote in one of his newspaper stories about that night was one of the most dramatic summations of the event. It is often repeated on websites and in books about the Super Outbreak: "It was like something out of the Old Testament, a pillar of clouds, black, majestic and ominous, moving across the farm land of Limestone County."

Bob continued his career as a well-known and respected journalist and published several books until his death in 1995.

"IT BROUGHT US CLOSER"

Donnie and Felica Powers of Limestone County are two of the few for whom the tragic events of April 3 had a happy ending.

Donnie was eighteen that day and his best girl, Felica, was fifteen when they hopped into his Mustang to follow Felica's aunt, who was trying to get her four children home before the weather worsened.

From the car ahead, Felica's Aunt Kay glanced in her rearview mirror and noticed that the young couple's headlights had disappeared. She thought they had turned around and gone home as the storm began to crash around them.

Instead, the red Mustang had disappeared from view because it had flipped numerous times, throwing Donnie and Felica from the car, and landed in mud.

Felica, not knowing that tendons in her ankle had nearly been severed, walked around and searched for Donnie, who had been struck hard by a flying rock in the back of his head.

Felica says now that mud must have held her ankle together. She was too dazed to know how injured she was. She only wanted to find Donnie, but she would not know of his fate until much later. She learned that the unconscious Donnie had been thought dead and was loaded in a hearse and driven to Huntsville Hospital's morgue. At the hospital, someone realized that Donnie was breathing but comatose. Eventually, he recovered. Felica also needed time to recover from her injuries.

A few months later, the teen couple married, with permission from Felica's parents.

Felica says that for all the misery the storm brought, "I've had thirty-something years of a wonderful life because of it. It brought us closer together, like we should have been."

Chapter 6
NOVEMBER 15, 1989

"This Is Not Natural"

BY THE NUMBERS
A summary of damage gathered by local newspapers the Huntsville Times *and the* Huntsville News *reported.*

259 homes destroyed
130 homes with major damage
148 homes with minor to moderate damage
80 businesses destroyed
8 businesses damaged
3 churches heavily damaged
2 schools destroyed
10 public buildings destroyed or heavily damaged
$1.9 million in public utility damage

S hannon Dickinson was driving along South Memorial Parkway in Huntsville at 4:30 p.m. on November 15, 1989.

As he approached the intersection of the Parkway and Airport Road in south Huntsville, Shannon noticed a huge dark cloud approaching from the west. "It was as black as anything I ever saw," he recalled. "It didn't look like a tornado; it was just a huge black cloud. It didn't look like *The Wizard of Oz.*"

Earlier that morning, Shannon had heard reports that severe weather would be moving in that afternoon, but it wasn't raining and he hadn't

heard reports of possible tornadoes. It was November, and most tornadoes that hit north Alabama came in during spring months, particularly March and April.

Shannon had the green light and crossed through the Airport Road intersection and continued straight on the parkway. He later wondered if the people stopped at the red light were among those who died on Airport Road that night.

"As soon as I crossed through the intersection, a huge gust of wind starts blowing all the leaves that were still on the trees from right to left. They were coming so thick, so fast and so hard, I couldn't see what was ahead. When I looked out the window to my right, it was totally black. To the left, it still looked like 4:30 in the afternoon," Shannon recalled.

Dark comes early in November, and at 4:30, the sun had started to set. Soon it would be dark. Shannon still could not see the road but wanted to pass through the storm rather than pull over, so he tried following the fence along the right side of the road, which he knew enclosed Huntsville Municipal Golf Course. He knew the hole along the fence; he'd played it before. It was about three hundred yards to the green.

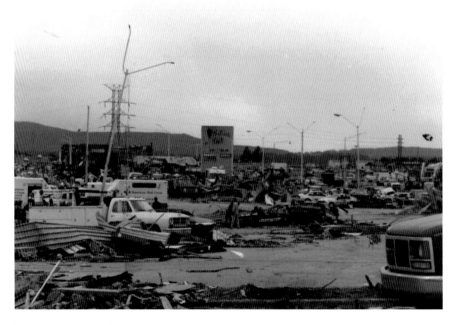

Westbury Shopping Plaza was demolished by the 1989 tornado that struck south Huntsville. *Courtesy of Jim Pemberton.*

"When I got halfway down, the leaves started going from left to right," he said. "I thought, 'What in the world? This is not natural.'"

Still, Shannon had no idea the danger the storm posed until he looked up and saw that suddenly the leaves were no longer moving horizontally. They were dancing in the air in front of him. "I thought, 'Good God, this is a tornado,'" he said.

Shannon hit the gas to try to outrun the storm, which by now was spitting hail. "It was terrifying to me," he said. He safely outran the storm. It wasn't until Shannon had completed his business and was driving back north through the same intersection that he realized what had happened. "It was dark by then. There were emergency lights and blue smoke everywhere. It looked like a war zone—like a bomb went off."

Shannon had driven through "the glancing edge" of a tornado that took the lives of 21 people, injured as many as 463 others and did $100 million in damage.

BLACK WEDNESDAY

Huntsville, the fourth largest city in Alabama, has about 180,000 residents. As the new millennium dawned, Huntsville was known as a technology center, home of NASA's Marshall Space Flight Center, the U.S. Space and Rocket Center, Redstone Arsenal and hundreds of industries supporting space and munitions. When Huntsville was founded as Alabama's first incorporated city in 1811, its residents earned their money raising cotton and building railroads.

Residents of northern Alabama are familiar with severe weather. By 1989, people could count on radio and television reports and a series of weather sirens to notify them of pending dangerous storms.

On November 15, though, even modern technology couldn't help the residents of Huntsville. That day in Madison County, meteorologists issued a severe thunderstorm warning and a tornado watch, which meant that conditions were favorable to spawn a tornado. A tornado warning is issued if a tornado has been spotted or if radar shows rotation that could possibly be a tornado. Warning sirens are activated during warnings.

Scientists monitoring the equipment at the Weather Service Office not far from Airport Road saw no indication of a tornado on radar. It wasn't until a tornado was spotted on the ground that sirens went off at about 4:35 p.m. By then, it was too late for many people, including the dozens who were in their cars, heading home from work.

Cars were tossed like toys by the November 15, 1989 tornado that struck Huntsville. *Courtesy of Jim Pemberton.*

After people saw the devastation caused by the storm, they referred to that day as Black Wednesday.

Huntsville was not the only city hit by a tornado that week. On November 15 and 16, forty tornadoes were reported from the South to the eastern U.S. and into Canada. Nine deaths occurred at a Newbergh, New York elementary school when it was hit by a downburst on November 16. Other significant tornadoes were reported across fifteen states, but no other deaths were reported.

Huntsville was hardest hit. The tornado that struck along Airport Road was ranked an F4, with winds up to 250 miles per hour. Twelve of the twenty-one killed died while in their cars.

Once the tornado was spotted and reported by a network of amateur radio operators, information was quickly disseminated over the NOAA Weather Wire Service, as well as on television and radio stations throughout Huntsville.

The tornado first touched down on Redstone Arsenal and then moved into a sparsely developed area, where it did $1 million in damage to Huntsville's garbage-burning plant that was under construction.

The storm began to cross the site of the old Huntsville Airport, which was adjacent to the municipal golf course. It struck Huntsville Police Academy, and two officers were injured.

The tornado crossed Memorial Parkway and traveled up Airport Road, a busy five-lane road connecting the parkway and Whitesburg Drive. It leveled businesses, homes, churches and Waterford Square Apartment complex.

Jones Valley Elementary School was heavily damaged. The children inside survived. *Courtesy of Jim Pemberton.*

Nineteen of the twenty-one deaths occurred between the intersection of Airport Road and South Memorial Parkway and the intersection of Airport and Whitesburg.

The storm then moved up heavily wooded Garth Mountain, where it struck Jones Valley Elementary School. Inside were thirty-seven students, who were in an after-school daycare program, and five teachers. Seven men were also in the school to complete a paint job. A teacher, realizing the danger, quickly but calmly told the children that they should go and play downstairs in the school's basement, which saved their lives. When the storm hit, some of the painters shielded children with their bodies, also saving lives.

One student's mother, Karen Jones, a forty-eight-year-old nursing instructor at the University of Alabama in Huntsville, was killed outside the school when she arrived to pick up her son, Andrew. She was unaware that he already had been picked up and was not in the school.

The tornado continued its path of destruction, hitting Jones Valley subdivision and then moving up Huntsville Mountain headed toward Brownsboro. The storm then crossed Red Mountain before dissipating at a small creek.

Among the damaged or destroyed structures were Huntsville Police Academy and K-9 training center, Crestwood Hospital and Crestwood Center's medical offices, Waterford Square Apartments, Country Club Apartments, Captain D's, Quincy's Steakhouse, Holy Spirit Catholic Church and school, Trinity United Methodist Church, Faith Presbyterian Church, Lucky's Grocery and other shops in Whitesburg Center, Winn-Dixie and other shops in the Village on Whitesburg, Golbro and other shops in Westbury Plaza Shopping Center. Once the tornado had crossed the mountain and entered the more rural parts of Madison County, it damaged houses, mobile homes and the Killingsworth Cove Volunteer Fire Department.

Among those killed was seven-year-old Godwin Yee, a student at Mountain Gap Elementary School, who was thrown from the family van as his mother drove toward the piano teacher's home to take his sister to a lesson. The family later learned that the teacher had called to cancel the lesson because of threatening weather.

Vanessa Hastings-Pool, a twenty-two-year-old nursing student, was killed. She had gone to her apartment in Waterford Square to take a nap before her night shift when the tornado hit.

John and Wanda Lewis, parents of seven children, owned Gates Cleaners. They were killed by falling debris inside the store.

Tragic stories were everywhere.

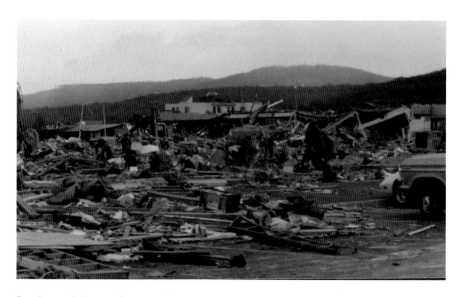

People search the wreckage on Airport Road on November 16, 1989. *Courtesy of Jim Pemberton.*

November 15, 1989

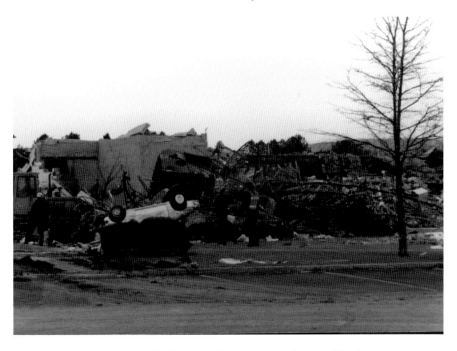

Witnesses stated that Airport Road looked like a war zone. *Courtesy of Jim Pemberton.*

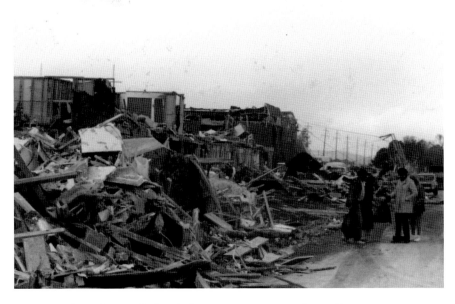

Hundreds of people were displaced when an apartment complex and homes were destroyed. *Courtesy of Jim Pemberton.*

"WE LOOKED UP AND SAW SKY"

Ten days before her wedding to Todd Brown, twenty-one-year-old Tara Alt was helping pay for her studies at Athens State University by working as a teacher in the after-school daycare program at Jones Valley Elementary School. She was one of five teachers watching thirty-seven students on November 15. She recalled the day as a warm one.

"It was a beautiful, gorgeous day," she said. "I was wearing a short-sleeved shirt. We took the kids outside to play on the playground."

When the rain started, the teachers planned to take the children to the gym to watch a movie. The gym was located in a separate building behind the school. Each teacher was responsible for children in a certain grade.

For some reason Tara cannot recall, the teachers decided that perhaps it would be better to skip the movie and take the children into the main school building. "We were sitting downstairs playing games in the hallway when the lights went out," Tara said. "Then the windows started popping. Then, all at once, they all blew out."

That's when Tara realized the danger. She saw another teacher across the hall struggling to open the door to the janitor's closet and push the children in her care inside. Tara tried to push her students toward the closet, too. "But the wind was so strong, they'd come right back. So I covered them with my body as best I could."

All of a sudden, it was over. "We were on the bottom floor of a two-story building. We looked up and we saw sky."

The young teachers had in their heads that the tornado might return, so they gathered the children and took them from the building. Then someone realized the danger of downed power lines, and the teachers and students went to stand near the road in front of the school. Tara recalled suddenly the weather turning "freezing cold."

"Parents started showing up to pick up their kids. Most of them didn't know anything had happened until they arrived and saw the school," she said. Chaos ensued.

By this time, it was dark. The school's protocol for signing out children was abandoned. Some parents took their own children, as well as those of friends or neighbors, in an effort to be helpful. "We couldn't tell if everyone was okay," Tara said.

They later learned that all of the students, teachers and the painters working inside had survived. Tara heard that one mother had just picked up

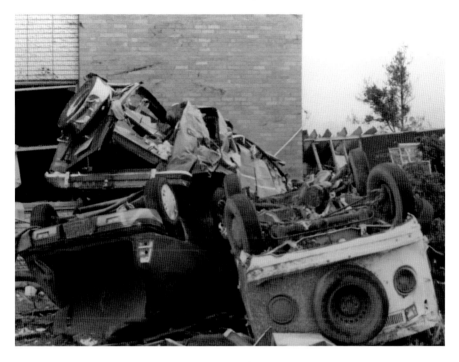

Airport Road resembled a salvage yard. *Courtesy of Jim Pemberton.*

her two children and that the three were in the parking lot when the storm hit. They raced toward the school and got back inside just as the school was hit.

Thirty-four-year-old Roy Campbell, a painter for the Huntsville City Schools system, was working with a crew of seven painters inside Jones Valley Elementary School on November 15. He went out to his truck to call his wife and daughter from his cellphone to be sure they were taking cover. "He could tell when something wasn't right with the weather," said Roy's daughter, Jennifer Cosby.

As Roy began walking back toward the school, the tornado hit. "It was just sitting in the parking lot, spinning," Jennifer said.

Rushing inside, Roy noticed a woman and child who were being sucked toward the funnel. "He fell on top of them," Jennifer said. "But he didn't have a scratch on him until he began digging out that little boy, Chris."

Chris Neuman was trapped beneath the debris, and his leg was seriously injured. Roy was struck with a concrete block during rescue efforts. "He heard Chris calling and started digging for him," Jennifer said.

Jennifer said that the storm had long-term impact on her father. He learned that he had a preexisting high blood platelet count and blamed the storm for his subsequent blood clots. In 1990, he had his right leg amputated. Within another decade, his left leg would be amputated, Jennifer said.

Roy, considered by many to be one of the heroes of the tornado of 1989, died in 2001. He was forty-six. The truck in which Roy had been seconds before the storm hit was overturned and crushed.

Another painter who was labeled a hero that day, Billy Dupree, also saw a long-term impact from the storm. The leukemia that had been in remission returned within weeks of the tornado. Doctors blamed the trauma of the storm.

Tara, too, was traumatized. She still has a fear of storms. She said that the parking lot of Jones Valley School had recently been paved and that her hair was covered in glass and tar during the storm. When she and her father returned to the devastated area the next day to look for her car with her wedding veil inside, she could smell the tar. "To this day, the smell of tar makes me sick," she said.

When it was rebuilt, much of Jones Valley Elementary School's first floor was constructed underground. The school's concrete hallways, as well as a row of rooms that serve as storm bunkers, are windowless.

"THE HAND OF GOD WAS OVER THEM"

English teacher Marcia Scarborough (now Keller) was in a faculty meeting at Grissom High School on Bailey Cove Road when the tornado warning sirens began to sound. Principal Sid Ingram immediately stopped the meeting and told teachers to go home before the storm hit.

Marcia's son, Jeffrey, was in third grade and stayed in the after-school childcare program at Jones Valley Elementary School until she was finished with her teaching duties each day. "I wondered if I should leave him there," Marcia said, thinking that he would be safe in the school. "But then I thought, 'No, he's afraid of storms, so I'll go get him.'"

She arrived at the school at about fifteen minutes after 4:00 p.m. The after-school care teachers were hustling the children downstairs to take cover.

"I took a chance by going over there," she said. "By the time we got home, the sky had turned greenish, the rain was coming down in horizontal sheets and the power had gone off."

Not long after she and Jeffrey arrived safely home, a friend called Marcia and told her that the school had been demolished by a tornado. Soon,

she visited the devastated school and heard tales of the painters who had been working that day and who had covered children with their bodies to protect them.

"They were heroes. If not for the responsible action of the after school care staff and the painters, those children would have died. The school looked like a bomb went off; the only area that was untouched was where the children were taken. The hand of God was over them."

Although the students had survived, some were traumatized by events of the day, Jeffrey Scarborough said. Karen Jones—the mother of Jeff's third-grade classmate, Andrew—was killed when she arrived to pick up her son, unaware that he already had been picked up by his father.

While still in the school's parking lot, Karen's car was lifted from the ground and flipped, landing in a nearby field.

Another friend, Chris Neuman, was injured when debris fell on him, pinning his leg.

"I'm still nervous about storms to this day," Jeff said.

"WE ALL STARTED RUNNING"

Scott Gilbert was twenty-four-years-old when he and a crew from his construction business pulled up to Riley's Food Store on Queensbury Drive to get soft drinks. The store was located across from Golbro department store.

"We walked out and I saw Golbro explode," Scott recalls. "We thought a bomb went off at first. The smoke was so black. We didn't see a lot of wind yet all these cars came tumbling by. A huge Dumpster container behind Riley's started spinning in a circle and shot up into the air and hovered above us. We all started running."

Before Scott could take cover, he was struck in his shoulder blade by a cinder block. The wound later took four hundred stitches to close.

Then the tornado was on top of them. "When that first wind came over, you could see clear up into a short, squatty tornado," he said. "It was wide at the base. Then there were five or ten seconds when you were in the center of it. You could see it all around you. The noise was indescribable. Our ears were popping so bad from the pressure."

Transformers were popping, too, as the tornado passed, knocking out power to much of south Huntsville.

"We didn't know which way to run," Scott said. When he and crew members realized that they were running into the funnel cloud's path, they

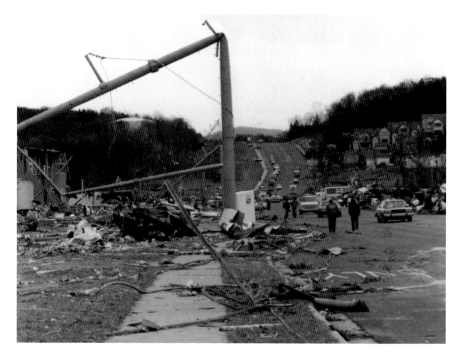

Massive utility poles were bent like plastic straws. *Courtesy of Jim Pemberton.*

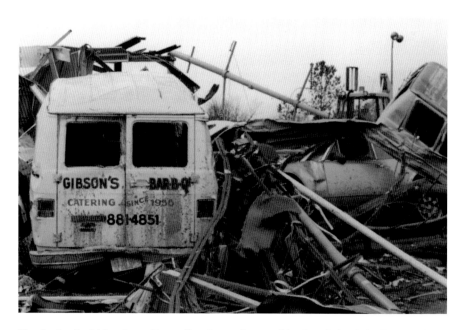

Hundreds of vehicles along Airport Road were destroyed by the winds of the F4 tornado. *Courtesy of Jim Pemberton.*

headed back toward Riley's. "I saw my Ford F150 truck upside down in the middle of Airport Road," he said. The tires were flat, and when he took it later for repairs, workers found the tires filled with pink insulation.

Scott said he will never forget what he saw that day. "I saw animals flying; I saw cars flying," he said. He recalled seeing a ceiling tile, which typically is easily broken, shot through the back window of a Thunderbird and lodged in the dashboard.

"We were painted black from asphalt blown up from the street. We couldn't scrub it off for four days. My shirt looked like it had been sandblasted. My pockets were packed full of gravel, as much as you could get in them," Scott said.

Scott's business checkbook was later found in Brownsboro, fifteen miles away, along with some wrapped gifts from Golbro. Scott and the crew hitchhiked home, and Scott tried to get into Huntsville Hospital to have his injuries treated. The emergency room was so packed with injured that Scott called his family pediatrician, who agreed to sew up his wounds.

"MAN, THAT CLOUD IS BLACK"

Fred Keith had just arrived at his Jones Valley subdivision home from his job at Raytheon Company when he noticed that "the sky didn't look too promising."

He worried about his wife, Mona, who was working in downtown Huntsville, and their youngest daughter, Lorri, who was working in the offices at Humana Hospital. If Lorri had already headed home, she would travel along South Memorial Parkway.

"I was in the kitchen, looking west and I thought, 'Man, that cloud is black,'" Fred recalls. "About that time, I heard it. When they say it sounds like a freight train, that's exactly what it sounded like. I headed to the bathroom."

When Fred reached the hall, a two-by-six piece of lumber flew through a window in the back bedroom, landing in the opposite end of the hall. Then, as soon as it had come, the storm was gone.

Mona and Lorri had remained safely at their jobs until the storm passed, and Fred and Mona thought that their home had escaped major damage. But the next day, as the couple prepared to gather blankets for people who were left homeless, Mona opened a closet door. "There was a huge hole in the roof and bricks piled in the closet," Fred said.

The bricks had come from Jones Valley Elementary School. "There also was a desk from the school in the large magnolia tree in the front yard."

Airport Road in south Huntsville was a scene of destruction after the November 15, 1989 tornado. *Courtesy of Jim Pemberton.*

In Fred's neighborhood, homes were damaged, but his neighbors were unharmed. "Fortunately, no one was hurt."

Not everyone in Huntsville would be so lucky that day.

FAITH, HOPE AND LOVE

Children also were saved from injury at Trinity United Methodist Church on Airport Road when a church member, who worked for Huntsville Emergency Medical Services, Inc., got a report of the approaching tornado on his radio and called the church with a warning, Marcia Scarborough recalled.

Children who were practicing for a performance of the hand bell choir were quickly ushered to the basement to take cover. Minutes later, all of the windows in the sanctuary blew out. The church sustained heavy damage.

Holy Spirit Catholic Church, located not far from Trinity along Airport Road, was practically demolished. Columns behind the altar bearing the words "Faith," "Hope" and "Love," were all that remained in the sanctuary. At the adjoining Catholic school, the 270 students had attended only a half-day, so only about twelve children and teachers in the after-school daycare program were inside when the tornado hit. They suffered only minor injuries.

Thankfully, no one was seriously injured inside the churches, but the damage played havoc for months with young couples who had scheduled weddings there.

Just weeks before the tornado, Bridget McGary had booked Holy Spirit Church for her wedding to Barry Sanders. They planned to be married

the following summer. The church was special to Bridget because she had attended the adjoining Catholic school, as well as the church.

"Growing up, I didn't think much about my eventual wedding day, but when I became engaged I just knew that I had to be married at Holy Spirit Church. So much of my spiritual development was rooted in that church."

Bridget had celebrated First Communion, First Reconciliation and Confirmation at Holy Spirit. "When the tornado hit both the church and school, I was upset to say the least. I was amazed at the photos of the church sanctuary that showed the 'Faith,' 'Hope,' and 'Love' inscriptions and the mural of Jesus still intact while damage was all around," she said.

Bridget and her fiancé were told to make new plans for their wedding, and they reserved a time at the Church of the Visitation. They later learned that repairs to Holy Spirit were completed the week before the couple's new wedding date.

"The only thing missing was the pipe organ, but the piano was in place and was all we really needed during the service. So, my wedding on July 14, 1990, ended up being the first one in the renovated church, post tornado, and my 'hope' for having my wedding in the church I had grown up in was realized," she said.

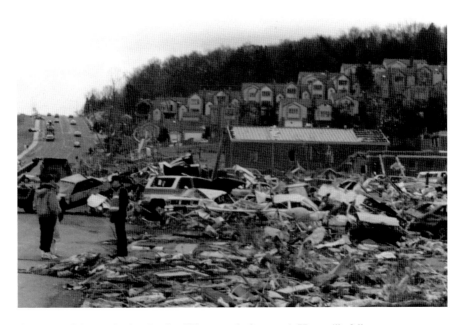

Clean-up of the site begins, but it will be years before south Huntsville fully recovers. *Courtesy of Jim Pemberton.*

Suzanne Keller planned to be married at Trinity United Methodist Church in February 1990. "It was my church and I loved it," she said.

After the tornado, "We wondered what on earth we were going to do. Holy Spirit was damaged, Trinity's sanctuary had been lifted up, put back down and would collapse at any moment."

Faith Presbyterian Church had been damaged, but a newly built sanctuary was spared. Suzanne booked the church for her wedding. "It was light and bright and beautiful, plus it had the benefit of being the only sanctuary around being useable by that time."

Suzanne was glad to discover later that one unbroken stained-glass window was saved from Trinity's sanctuary and installed in the new building's narthex. "I got teary remembering how much I loved that place and how glad I was that they saved that piece of our history," she said. "I know many people weren't that fortunate and feel blessed that no one I knew was killed. It was a horrible event that changed many people."

"I JUST SCREAMED HER NAME"

For a few hours, she was known only as "Kathy Doe."

She had been able to give her first name to emergency workers before everything went black. Finally, her husband of eighteen months found her at the hospital and told the attending nurses that her name was Kathy Sharp.

Kathy, who was a second-shift pharmacy technician at Huntsville Hospital, had been at home in the Waterford Square apartment she shared with her husband Johnny when the tornado hit on November 15. She had noticed that the air felt "sticky" and called Johnny at work to tell him that she thought the weather was going to get bad.

Five minutes later, the storm hit. Kathy and Johnny would never be the same.

Johnny and his coworkers went downstairs to take cover. They had on a radio and television to listen to storm reports. "I kept trying to call Kathy," he said. "There were no cellphones so we kept taking turns with the phone. I called her every five minutes."

When the danger had passed, a coworker drove a panicked Johnny to Airport Road. The entrance was blocked by police cars. He got out of the car and ran. When he reached the apartment complex, he found his building "totally wiped off its foundation."

A monument at the intersection of Airport Road and Whitesburg Drive in south Huntsville is inscribed: "In memory of all who experienced loss; in tribute to all who united for care and recovery; the tornado of November 15, 1989." *Photograph by Melanie Flanagan Elliott.*

"Our building was pushed out in the middle of the road," Johnny recalled. He dug through the rubble, frantically searching for Kathy. "I just screamed her name," he said. "I was pretty much in a daze."

Finally, Johnny reached a family member who worked in the hospital office and learned Kathy had been transported there. He went from desolation to ecstasy within seconds. But when he arrived at the hospital, he received more devastating news. Kathy couldn't breathe on her own. Her spine had been severed.

"I was probably struck by a car," she said. "I was standing in the bathtub. You could hear the walls cracking. I prayed and closed my eyes." When she became aware again, "I was in a lot of pain and scared to death."

"I was thankful she was alive," Johnny said.

Kathy and Johnny suffered post-traumatic stress following the tornado. In the hospital, during her recovery, Kathy read that 87 percent of marriages fail after a spouse is paralyzed. She was determined that she and Johnny would be in the 13 percent.

So far, they have made it. Both admit that it hasn't been easy.

"It's been difficult for both of us," Johnny said. "But we're determined."

Chapter 7
MARCH 27, 1994

"She Sang, She Danced, She Painted, She Climbed"

Kelly Clem clutched the stuffed toy, a pink mama cat with three tiny plush kittens. It had been a favorite of Hannah's, her four-year-old daughter.

Did Kelly realize, in her grief, that she was clinging to a symbol of motherhood, a mama who nurtured her babies? Or did her hands, aching to hold Hannah, simply need contact with something her little girl had touched?

It wasn't an important question, not when there were so many already: questions from reporters (Was it God's will? Has your faith been shaken?), questions from parishioners (Why us? Why our church?) and, finally, questions from the funeral home (In what outfit should Hannah be buried? Where will she be laid to rest?)

On March 27, 1994, after a tornado struck Goshen United Methodist Church in Piedmont and took twenty lives, questions were plentiful.

The answers were more difficult to find.

"IT WAS LIKE A BATTLEFIELD"

Even at four years old, Hannah Clem knew God.

She knew him as a pal and often talked to him aloud as a child talks to an imaginary friend. But God wasn't imaginary. To Hannah, God was very real.

He could be found not only on earth but also watching over heaven, a place she believed to be much like Disney World. The fact that both of

Hannah's parents were pastors likely played a role in her strong faith, but the ease with which Hannah accepted God in her life and her reverence for her small child's Bible sometimes surprised even the Reverends Kelly and Dale Clem.

"She would throw a ball up into the air and say, 'God didn't catch it,'" Kelly Clem said during an interview by respected meteorologist James Spann for Birmingham's ABC 33/40. It aired on the tenth anniversary of the storm.

The morning of March 27 was busy in the Clem home, the parsonage next to Goshen Church. Dale was seven hundred miles away in Oklahoma, where he had taken students on a youth service trip. Kelly was home trying to ready the girls, Hannah and two-year-old Sarah, for the special drama that would be performed for Palm Sunday during the morning worship service. Kelly dressed Hannah in her pink dress and matching tights and poured three bowls of cereal.

Then the three Clems walked over to the church. Hannah begged to skip Sunday school and help her mom prepare for the drama, and Kelly relented.

Hannah Clem. *Courtesy of Dale and Kelly Clem.*

The drama was to begin at 11:00 a.m. Kelly looked around the church and was pleased to see so many people. More than 140 were in attendance, in excess of the church's total membership of 132. Visitors had come from several states; everyone was looking forward to the play.

During children's time at the front of the church, Kelly asked the congregation, "Have any of you ever seen this many children in church on a Sunday morning?"

Kirk Scroggins was to portray Jesus, and Kelly thought that the single father was a particularly good choice for the role. "He had a real crown of thorns," Kelly recalled. Kirk also carried a rugged cross on his back, a wooden one that had been lovingly made by a parishioner.

The drama began. Children waved their palm fronds and the cast sang. Little Hannah watched from near the front. Sarah was in the back with a babysitter. It had been raining that morning, but there were no warnings of tornadoes. Even if there had been, no one kept a weather radio in the church. Just after 11:20 a.m., the power went out. Without the taped songs, performers attempted to continue the drama by singing without accompaniment. But then came hail and high winds.

April Kuykendall, who was seven, remembered taking hold of Hannah's hand. They began to run toward the adults. "I just remember running," April said.

April had the feeling earlier that morning something bad would happen that day. "Something didn't feel right," she recalled. At 11:39 a.m., the church collapsed; the roof over the congregation fell onto the people below. The survivors didn't know until later that a tornado warning had been issued at 11:27 a.m.

Nearly all of those inside were trapped by rubble.

"It was like a battlefield," Kelly said later. People were covered in dust. She said a one-word prayer: "'Help.' I just prayed, 'Help.'"

Kelly had been hit in the head with a brick and suffered a dislocated shoulder, but she began trying to make her way to where Hannah had been, knowing that everywhere she stepped were the injured and dying. She remembered feeling guilty when she didn't stop to help. She had to get to her child.

When she reached the area where her oldest daughter had been, Kelly saw little Hannah beneath a pew, pinned by rubble. Kelly spoke soothingly to Hannah, letting her know that her mother was with her. But the young pastor knew that her daughter was dead. Her skin was cold and gray.

From the back of the church, someone held up little Sarah so Kelly could see that her youngest child was unharmed.

Twenty people died in Goshen Church that day. Ninety were injured. Among the dead were entire families.

March 27, 1994

Here is a list of those who died, as well as notations of their family members who were injured:

- David Kuykendall, father of April, died. April was injured.
- Derek and Kay Watson, who had celebrated their third wedding anniversary a few days before, died, along with their daughter, Jessie, eighteen months.
- Michael and Kathy Mode and their son, Zachary, three, perished.
- Jonathan Abbott, age five, was killed. He was attending church with his grandfather, Earl Abbott, age fifty-five, who also died.
- Marcus "Buddy" Woods Jr. and his daughter, Amy, age nine, both died. Mary Woods, Buddy's wife and Amy's mother, was seriously injured.
- Amy Woods's cousin, Eric Thacker, a seventh-grade student, was killed. His two sisters were seriously injured.
- Diane Molock, a forty-two-year-old nursing supervisor at Jacksonville Hospital, perished.
- Ethelene Blair, age fifty-four, was killed, as were brother Cicero Peek, sixty-four, and sister Ruth Peek, seventy-two.
- National Guard sergeant Fredrick "Freddy" Bass, a large man of about six feet eight inches and three hundred pounds, was among the victims. He had tried to help worshippers take cover before a huge concrete beam fell from above. His body was taken along with the others to the temporary morgue at the National Guard Armory.
- Among the dead were Kirk Scroggins, thirty-seven, who had not yet made his entrance into the sanctuary to portray Jesus's crucifixion, and Kirk's father, George Scroggins, age seventy-nine.

Someone, within hours of the tornado, placed the cross that was to be used in the drama into a concrete block stand at the entrance of the sanctuary. It was a symbol of all that was lost and of all that was saved.

The tornado that hit Piedmont in Cherokee County was ranked an F4. It also killed one person in St. Clair County that morning and another in Calhoun County.

The 1994 tornado outbreak was the third major outbreak to occur on Palm Sunday and the second to hit the Southeast.

Twenty-seven tornadoes—nine F0s, five F1s, four F2s, seven F3s and two F4s—struck that day in Alabama, Georgia, South Carolina and North Carolina, killing 42 people and injuring 320. They caused $140 million in damage.

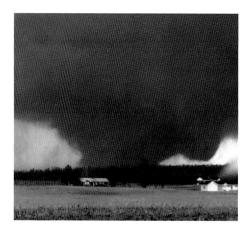

This tornado struck Piedmont and killed twenty people inside Goshen United Methodist Church on Palm Sunday, 1994. *Courtesy of National Weather Service.*

The country's deadliest Palm Sunday outbreak was on April 11, 1965, when forty-seven tornadoes hit the Midwest, killing 271 people and injuring 1,500. Unlike the 1965 outbreak, the 1994 outbreak was mainly confined to the southeastern United States.

In addition to the F4 that hit Piedmont, five tornadoes struck Alabama on March 27, 1994: an F2 in Marshall County; an F3 in Rainsville and Sylvania in DeKalb County; an F0 in Blount County; an F0 in Tuscaloosa County; and an F2 in Pelham, Indian Springs, Helena and Inverness in Shelby County.

Weather forecasters in the area had been using the high-tech Doppler radar for about a year. The tornado warning that had been issued twelve minutes before the storm hit was considered adequate time for people to take cover. At Goshen Church, though, those in the congregation had no way of knowing that the warning had been issued. There were no outdoor sirens and the church had no weather radio.

"A LESSON IN GRACE"

On Wednesday, April 30, Vice President Al Gore visited the ruins of Goshen Church.

President Bill Clinton, who was vacationing in Southern California at the time, declared the affected Alabama towns as disaster areas that same day, making federal funds available for recovery efforts. Later, Clinton sent a note of condolence to the Clems.

Before Gore's arrival, Dale made a statement to the press. He told people who wanted to donate to the new church building to look around and see

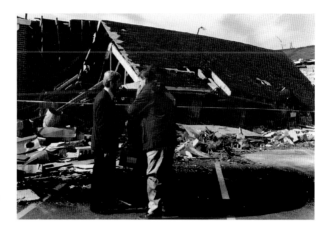

The Reverend Dale Clem stands by his wife, the Reverend Kelly Clem, as she gets a hug at the scene of the tornado that killed the Clems' daughter, Hannah, four. *Courtesy of Dale and Kelly Clem.*

who needed help in their own communities. "We just encourage people to keep loving better," Dale said.

The Associated Press reported that when Gore met Kelly and Dale Clem, Kelly's face was still bruised and swollen from her injuries. "I'm in awe of the strength and grace you've shown through this," Gore told the couple. "On behalf of the country, I want to thank you for this lesson in grace." But more than the vice president were awed by Kelly's actions in the moments following her daughter's death. She continued to aid other grief-stricken parishioners and lead her congregation, despite her own grief.

In his book *Winds of Fury, Circles of Grace*, Dale quoted Kelly's comment to reporters: "We are still the church. The church is not the building, but the church is the people."

Gore began work as soon as he left to ensure better warning for Alabama's rural communities. The next day, he announced that one hundred new emergency radio broadcast centers would be built with the ability to activate weather radios. One was installed near Piedmont before year's end.

"BLOSSOMS OF NEW LIFE"

Reporters repeatedly questioned survivors of the storm, particularly Kelly and Dale Clem, about their faith. "Do you blame God?" they would ask.

Dale and Kelly insisted this tragedy was sent by nature and not by God. "I don't believe that God caused the tornado to hit the church," Dale said. "God doesn't decide who will suffer and who will not. A tornado caused my daughter's death—not God."

He viewed the time he had with his daughter as precious. During the ABC 33/40 interview, he said, "Hannah was not mine. She was a gift to be enjoyed. I received a gift of four years, and that's all."

Still, to many, the suffering was unfathomable. Hundreds of people came to see little Hannah before she was consigned to the earth and to pay respects to the Clem family. At the funeral home, Kelly and Dale stood for hours shaking the hands and accepting the condolences of those who walked past.

Hannah was laid in her tiny pink coffin, wearing the aqua-green dress she would have worn to church on Easter Sunday. Her dark lashes lay against her cheeks, and Dale looked at his little girl and thought, "Get up. Get up."

The church where the service was held was decorated with Hannah's drawings and paintings. One drawing, called "The Fuzzy Bear," soon appeared on T-shirts in her honor.

Finally, the family went to Huntsville, Alabama, Dale's hometown, where Hannah was buried at Huntsville Memory Gardens. Her grave marker was engraved with a rainbow and the words "She Sang, She Danced, She Painted, She Climbed."

Back in Piedmont, the Clems tried to adjust to a different reality. They were living and worshipping in temporary quarters. The church was still a

Someone placed a crude cross at what once was once the entrance of Goshen Church. *Courtesy of National Weather Service.*

This monument was built at Goshen Church in honor of those who lost their lives in the March 27, 1994 tornado in Piedmont. *Courtesy of Bill Wilson/the Anniston Star.*

pile of rubble, which posed a hazard to workers; months after the tornado, crews decided to burn what remained.

Dale was frustrated that no one thought to remove the beloved cross that had been lovingly handmade by an older parishioner who had died before the storm. A few days after the fire, Dale took a friend into the ruins.

There he spied the cross. "There was a place where the rubble was cleared and the soot was thin. There in this place lay the wooden cross. I shouted and ran and picked up the sentimental cross. It looked as if it had no marking of the fire. Chill bumps ran across my body. I wondered if I had witnessed a miracle…Standing there holding the cross, I thought, 'This cross endured and I will endure as well.'"

The family received another sign from God that spring. Kelly had noticed a row of pansies growing alongside the house. Hannah had helped her plant the flowers the Friday before the tornado.

For months, the pansies flourished. Dale wrote in his book, "It was as if Hannah's spirit was giving us a sign of her ongoing life and the blossoming of her new life."

The Clems' lives, too, have gone on. As of 2010, the family was living in Huntsville with Sarah, eighteen, and Laurel Hope, thirteen, born two years after the deadly storm. Both Kelly and Dale still lead congregations.

Chapter 8
BIRMINGHAM IN 1956, 1977 AND 1998

"Whole Communities Were Wiped Out"

At seventy-seven, Elizabeth Shoemaker Massey Salter had buried two husbands, raised five children and spent years as a beloved and no-nonsense "lunchroom lady" at several schools in the area. She wasn't afraid of much.

Still, on April 8, 1998, Elizabeth—called "Bib" by her family—agreed to leave her home in Concord, a small community just outside of the booming metropolis of Birmingham, to take cover from an approaching storm at the home of her stepdaughter, Joy, whose house was just behind Elizabeth's home.

It seemed that everyone was concerned about the weather that night. An elderly woman shouldn't be alone.

The people of Concord and its neighboring towns had reason to fear. Twice before, deadly tornadoes had passed through the cluster of communities just southwest of Birmingham and east of the Warrior River and the Walker County line.

Oak Grove, Pleasant Grove, McDonald Chapel, Edgewater, Sylvan Springs and Maytown—all towns whose names spoke of their picturesque quaintness, their residents' wholesomeness, dogged hold on tradition and belief in God, family and community. All were accustomed to taking shelter in spring when storm warnings were issued, particularly in March and April. It almost seemed a test that tornadoes so often came down from the heavens during Holy Week, striking their schools and churches, their homes, their loved ones and their hearts and souls.

In 1977, a tornado that would become known as the Smithfield Tornado, named for the area hardest hit, touched down on April 4 during Holy Week. It was the strongest to hit Jefferson County up to that point. That spring in 1977, people were still talking about the deadly McDonald Chapel Tornado that hit the Birmingham suburb on April 15, 1956, twenty-one years before.

Now, another twenty-one years had passed since the 1977 storms. Residents knew the history. They were on alert. After two decades, though, memories of the devastation and the danger can fade.

On April 8, 1998, the Wednesday before Easter, Elizabeth Salter had decided that the worst of the severe weather had passed. Despite her stepdaughter's pleas, she insisted on returning to her house. After all, the devout woman knew that if a storm came and took her away, she was ready for heaven.

She had been home for only a few minutes when another wave of storms gathered strength above. Soon the winds reached unprecedented speeds, faster and deadlier than the tornado that caused such devastation in 1977. When they finally stilled, Elizabeth's home was gone, along with her furniture, appliances, clothing and photos—every possession.

But where was Bib Salter?

THE MAGIC CITY

Birmingham, the state's largest city, is set just north of the center point of the state. If a bull's-eye were drawn on the map, Birmingham would be in the target range, and severe weather takes aim at it often.

The city has seen more than its share of destructive tornadoes. With roughly a quarter of the state's population living in the Greater Birmingham Metropolitan Area, these storms put many lives in danger.

Named for the city in England, Birmingham is the seat of Jefferson County and spills over into parts of Shelby County. During the industrial age, it earned the nickname "Magic City" because of its astonishing rate of growth. Nearby deposits of iron ore, coal and limestone—the three main raw materials used in making steel—led to the city's boom. It is the only place in the world where significant amounts of the three minerals can be found in such proximity.

Geographically, Birmingham is located at the end of the Appalachian foothills, which creates a series of mountains and valleys, the perfect places for tornadoes to form undetected.

As in any major city, many people flocked to the suburbs to take advantage of the benefits of urban life while raising families in safer, more

rural environs. In some of these small towns, people made their living in coal mines. Suburbs are places where people work and study hard all day; then people spend the remainder of their time with their families and in church. But tornadoes don't bow to the needs of man. They have their own agendas, and three times they have struck at the hearts of the suburbs of Birmingham, treating homes, churches and schools with equal disdain.

On the morning after the April 8, 1998 tornado, residents woke to see tornado devastation unlike any seen before. A total of sixteen tornadoes struck across the South on April 8 and 9, including the one that hit the Birmingham area, which became known as the Oak Grove Tornado. It was one of the deadliest single tornadoes in Alabama history.

Statewide, 35 were killed the night of April 8. At least 221 were injured. An F5 tornado, the second in Birmingham's history and the fifth to hit the state, had torn through Edgewater, Oak Grove, Rock Creek, Concord, Pleasant Grove, Sylvan Springs, Maytown, McDonald Chapel and Pratt City. In these towns, more than one thousand homes and businesses were destroyed. The hardest hit were Oak Grove and McDonald Chapel.

Oak Grove High School was damaged beyond repair. The elementary section of the school was completely destroyed. Thankfully, no students were inside when the storm hit. Fire stations at Oak Grove and Rocky Creek also were destroyed.

The deaths of Deb Helms and her sons—Colby, eight, and Carson, four—particularly stunned the communities. The family had taken shelter in the basement, as generations before them had done, when a wall collapsed on top of them.

Vice President Al Gore, who flew over the damaged communities by helicopter, called the damage "unprecedented."

Two churches were damaged, but their parishioners were unharmed. The roof was blown off Rock Creek Church of God, and at the Open Door Church, several members took shelter in the hallways and survived, though the church sustained heavy damage.

The tornado lifted from the ground just before entering downtown Birmingham—Birmingham International Airport would have been directly in its path.

The storm touched down again just before 9:00 p.m. in St. Clair County, where two people were killed inside a mobile home in Wattsville. Bethel Baptist Church in nearby Odenville was destroyed minutes after its parishioners left a rehearsal for an Easter drama.

In all the towns, the search for the missing and the dead had begun.

"THE HOUSE IS GONE AND MOM IS MISSING"

Jimmy Massey went to bed on April 8, 1998, unaware that his mother's home had been in the path of a deadly tornado.

At about 1:00 a.m., he was awakened by a call from his stepsister, Joy, about his mother, Elizabeth Salter. "She said, 'The house is gone and Mom was missing,'" Jimmy said. He rushed to Concord but was unable to get to his mother's home.

Local sheriff's deputies, firefighters and rescue workers blocked all entrances to the community until the coroner could finish his work.

"They gave me word at about daylight that my mother was one of the victims," Jimmy said. "She was found in the ditch across from her house."

Authorities didn't need Jimmy or Joy to make an identification. In Concord, just as in neighboring Oak Grove, Edgewater and Pleasant Grove, everyone knew everyone. "The firemen knew my mother personally. Almost everyone there had known her since they were children," Jimmy said.

Jimmy notified Elizabeth's younger brother, H.G. "Hootie" Shoemaker, who lived in Pleasant Grove. Like Jimmy, Hootie had been unaware that a deadly tornado was approaching his sister's neighborhood.

Earlier in the evening, he had sat on the front porch with his grandson and realized that a tornado must be passing. "We could smell the pine," he said. "We knew it was going across."

Places with the word "Grove" in their names are often surrounded by thick forest. Some residents, like Hootie, knew that the smell of fresh pine meant that something deadly was cutting a swath through the woods, snapping trees like pencils.

Hootie went to the scene of his sister's death the next morning. "All that was left was the driveway," he said. Jimmy said that a wall of the kitchen lay in his mother's front yard and that the refrigerator was in the ditch where she was found but that no other appliances or furniture were ever found.

In her will, Elizabeth had written that she wanted her best rings to go to various granddaughters. In the days after the storm, someone found a ring. A nephew with a metal detector joined the search, and in a strange twist, every ring mentioned in the will was found in the yard and given to its intended recipient.

Hootie, whose sister was ten years his senior, still misses her, especially at Christmas. "She fixed me a fruitcake every Christmas. I miss that," he said.

Jimmy has a last image of his mother. In it, she is not cowering against the storm. "My mother raised all of us to respect the weather but not to be afraid of it," he said. "I picture her watching TV and crocheting when it hit. I'm sure that's exactly what she was doing."

"I THOUGHT WE WOULDN'T SURVIVE"

Terry Hyche, a battalion chief for the Concord Fire District, was on duty at Fire Station 3 on April 8, 1998.

It had been raining all day, and the area was under severe weather warnings. Terry took a break and went to his home less than a mile away to check on his wife, Kathy, and their sons—David, eight, and Kyle, six. Kathy's sister, Rachel, was visiting.

Nothing seemed amiss at the Hyche home.

At about 7:50 p.m., Terry stepped out on the front porch and looked toward the skies. In the dark, there wasn't much to see. The air was still, so Terry wasn't too concerned about a possible tornado.

Lightning periodically illuminated the sky, giving Terry a glimpse of a huge, dark shape in the distance. Suddenly, he noticed that it was getting closer. Then the power went out. Terry could see that the shape had hit Oak Grove High School and Station 3. "It was a giant green wall," he said. Then the wind picked up, and a gust "about blew me off the porch."

That's when Terry knew what the black shape was. He raced inside the house and yelled for everyone to take cover. He and Rachel retrieved a mattress to protect the family from flying debris. "The house was shaking," he said. "You could feel the pressure in your ears." When a large tree fell through the roof above them, the pressure was relieved. Terry grabbed his radio and yelled to the dispatcher to "send everything she had."

Seconds later, the winds had passed. But the worst was far from over. "I always compare it to a terrorist attack," he said. "In a matter of a few minutes, we had a lot of casualties. It closed roads, crippled law enforcement, crippled fire and rescue and took out phone and power lines."

Terry discovered that the storm had hit two of the district's three fire stations, those in Oak Grove and Rock Creek.

Help arrived within about thirty minutes from crews in Hueytown and Bessemer, but the work was difficult. Men with flashlights went street by street and house to house, checking to see who was injured or dead.

The firefighters for the Concord District, which covered forty-three square miles, provided fire protection and medical assistance for three tiny burgs outside of Birmingham: Concord, Rock Creek and Oak Grove. In all, the three communities had about 2,500 residents; Oak Grove was smallest, with about 700 souls.

Ernest Chapel Cumberland Presbyterian Church in America was destroyed. *Courtesy of Bill Wilson/the* Anniston Star.

Terry lived closest to the Oak Grove station, where Scott Swindell had been forced to take cover in the equipment bin of a truck as the metal building collapsed around him. He was unharmed.

At Oak Grove High, cheerleaders had been practicing in the gym when it began to shake. They rushed to the lobby of the gym, which was made of brick, and survived the storm, although some of the girls had been injured by flying debris. The school was demolished.

Terry tried to calm his panicked family but then told a sobbing Kathy that he had to leave. He had to help others. He walked along his street, checking an overturned mobile home. It was empty. Then he checked on the family whose garage had been demolished. Everyone was fine. Another woman and her children were lying in a ditch, tangled in the limbs of a fallen tree. They were able to walk, so Terry sent them to a neighbor's home.

Terry arrived at the station, and he and other rescue workers took all the equipment they could find and set out to see who needed help.

One woman and her daughter were seriously injured and had to lie in the rain for as long as two hours before anyone could get to them. "We had to crawl through the debris," Terry said.

A tattered flag still flies in Oak Grove following the 1998 tornado. *Courtesy of Bill Wilson/the* Anniston Star.

Finally, by about 2:00 a.m., rescue workers from the Concord Fire District, Hueytown and Bessemer had checked every home. In Oak Grove, three were dead. Eleven had been killed in Rock Creek.

Terry will never forget the sights and sounds of that horrible night. "They say it sounds like a freight train, but it sounded like a bunch of jet engines to me," he recalled. "As big as it was, I thought we wouldn't survive."

"EDGEWATER IS GONE"

On the surface, a web page built by Walter Kirkwood Jr. looks like any other historical record of a small town. It tells of the town's founding in 1910 as a mining community for the Tennessee Coal and Iron Company.

It talks of how the Baptists and Methodists shared a building and alternated services for many decades before the Methodists finally took the space over. Walter describes community events such as games between local baseball teams, boxing matches and the annual Christmas gathering in the Guild Hall. Children were active in Campfire Girls and Scouts.

After just a few sentences, readers discover that this page is a eulogy, a love letter to the tiny town that nurtured him, grew around a coal mine and died

at the hands of nature's wrath. On April 8, 1998, Walter stood at the top of the stairs in his home in Pinson, thirty miles from the town of Edgewater, as a storm raged overhead. His wife, Shawnette, and children, Keila and Kayla, already had gone to the basement to take cover. The baby, Jade, was sleeping, and Walter was waiting to see if he needed to wake her.

Walter, a ham radio operator, was getting reports from storm spotters for the National Weather Service. In Pinson, the power already had gone out. "Flashlight in one hand and radio in the other, I heard panic in the voice of some Hueytown Police officers as they urgently called out for information," Walter recalled. Then he heard life-altering words: "There is a tornado on the ground near Concord. I think it's heading toward Pleasant Grove. Can anybody see?"

Silence followed. The storm spotters could see very little in the blackness of night. But then reports began to filter in. "Not long afterward, a shaky voice came on and announced, 'There has been a touchdown in Edgewater. We need ambulance and rescue immediately,'" Walter said. "The same voice came soon afterward and said simply, 'Edgewater is gone.'"

Walter's dad, Walter Sr., and his mom, Doris, lived in Pleasant Grove, but both had grown up just two miles away in Edgewater. Walter Sr. was also an

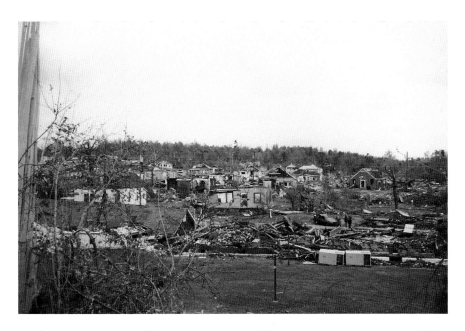

Much of the community of Edgewater, a suburb of Birmingham, was destroyed by a 1998 tornado. *Courtesy of Walter Kirkwood Jr.*

amateur radio operator and was monitoring the weather. "When the warning for our area was given, we retreated to our basement until we thought the storm had passed," Walter Sr. said. "I went out the basement door, and the strong odor of pine was prevalent. I went back into the basement and told Doris that I believed a tornado had passed nearby."

Walter Sr. heard the same reports on his radio as his son and knew that Edgewater had been hit. Doris immediately grew concerned for her aunts, her mother's sisters, who lived in Edgewater. Because the roads were blocked by downed trees, Walter Sr. and Doris climbed through branches of the trees to reach town.

"We arrived before any emergency personnel were there," Walter Sr. recalled.

It was a totally eerie scene. The only lights were the flashlights of the residents wandering around. We smelled the gas and could hear the hiss of natural gas escaping from broken pipes that were wrenched from the houses that were destroyed. Doris and I were raised in Edgewater, but the appearance of the village had changed so much that we became disoriented and had difficulty finding her aunts' house. We managed to identify the right street and walked to where the house was supposed to be, but it was gone, except for a little concrete. We were standing in the street, and Doris thought she heard the voice of one of her aunts. Her mother's two sisters were under the front porch of a house across the street. The front porch was several feet above the ground and they were huddled there to escape the rain. We later found out that the ladies were sitting in chairs in a small hall by the bathroom when the storm carried the house away and left them unscathed. We led the two ladies into the street, and they seemed to be in shock.

After depositing the women safely with a relative, the Kirkwoods went to see what had become of their hometown. Both of the homes where they lived as children were gone.

"The church we grew up in, married in and still had family in was completely gone…Although it was a brick building with large timbers of heart pine reinforcing the roof, it was totally destroyed. Its heavy bell was tossed across the street," Walter Sr. said. "It seemed that in a very few minutes our past was blown away as if it no longer existed nor will it ever exist. We cannot ride by the homes we loved so dearly nor visit the church building of our childhood. It only survives in our memory."

Birmingham in 1956, 1977 and 1998

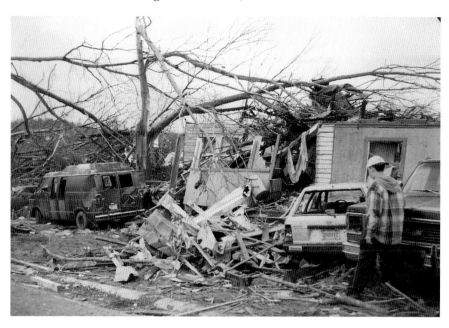

Above: The day following the storm, residents were allowed to visit their homes to see what they could salvage. *Courtesy of Walter Kirkwood Jr.*

Right: A devastating F5 hit several suburbs of Birmingham, including Edgewater. *Courtesy of Walter Kirkwood Jr.*

Walter Jr., who also had played in the homes where his parents grew up and attended the little Methodist church, was similarly affected:

> *All that this town was and all its history was blown away in an F5 tornado on the night of April 8, 1998. With very few exceptions, almost every house in the community was destroyed or damaged beyond repair. Some of its residents died as a result. It was a special place to live that was a product of the time. A time that will never again be in America. Whole communities were simply wiped out or severely damaged—Oak Grove, Concord, Sylvan Springs, Edgewater, McDonald Chapel, Pratt City. It's hard to judge which towns took the worst beating, but Edgewater was essentially destroyed.*

"WE GOT THE CROSS OUT"

Brian McKay of Sylvan Springs was home from work sick on April 8, 1998. He had taken medication and gone to bed when his daughter, Andrea, came in to tell him that television meteorologist James Spann was telling everyone to take cover.

"I heard if you're in Sylvan Springs, take cover immediately," he said. "I went out onto the deck, and I heard it." He knew the sound. A tornado had struck in Tuscaloosa when he attended the University of Alabama. "It was much more ominous than the one I'd been in before," he said. "If you've ever heard one, you won't forget it."

He and Andrea rushed to the basement of the home. Brian's wife, Kathy, was at work. Brian told Andrea to get inside a heavy, oversize cedar toy chest that was attached to the floor. "I said, 'Don't come out until I tell you to,'" he recalled.

Brian called his parents, who lived five miles away in Pleasant Grove, to tell them that he and Andrea were in the basement and to be sure that his parents also were taking precautions. Then the cellphones went out.

He and Andrea waited fifteen minutes before emerging.

Many homes in Sylvan Springs had been destroyed but the McKay home was undamaged. Then Brian heard that Edgewater, where he had lived as a boy, was devastated. He tried to get to his parents' home, but roads were blocked by downed trees and power lines.

Finally, he arrived at his parents' house to find that they were unharmed. He and his dad set out to help people in Edgewater. Brian thought that

A piano keyboard lies in the ruins of the Methodist church at Edgewater. *Courtesy of Walter Kirkwood Jr.*

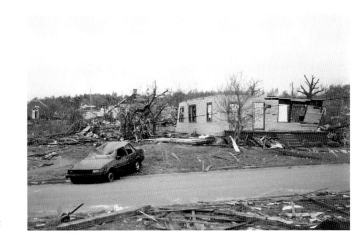

The homes that were not demolished were damaged beyond repair. *Courtesy of Walter Kirkwood Jr.*

everyone would likely be at the Methodist church, a gathering place in the tiny community.

The building was sturdily built and centrally located. Brian and Kathy had been married there. "I knew the church would be there," he said. "Then I came around the curve, and the church was just gone. I remember just thinking 'What?!'"

Despite still being ill, Brian and his father worked to clear debris and look for people. Some, like Sunday school teacher Beatrice Anderson, did not survive.

Working inside the demolished Methodist church, Brian and other workers searched for a large old Bible that always sat on the altar and an old

Trees and utility poles were uprooted by the strong winds. *Courtesy of Walter Kirkwood Jr.*

rugged cross made of railroad ties. They found both. A television news crew filmed Brian and his father removing the cross from the church.

"We got the cross out," he said. "There was not a scratch on it."

1977: WAS IT AN F6?

Twenty-one years before the deadly 1998 tornado, the worst tornado in Alabama's history hit on the afternoon of April 4, 1977.

In just minutes, twenty-two people lost their lives and as many as two hundred homes were destroyed when a powerful F5 hit in Smithfield Estates near Pratt City. In that subdivision, two children were found dead at the bottom of a fifty-foot bluff.

A busload of children near the storm's path survived, though. Just before the tornado hit North Smithfield Manor, Fultondale Elementary School students on their way home to the subdivision sat on a school bus and watched a dark cloud approach and head directly toward their neighborhood.

Birmingham in 1956, 1977 and 1998

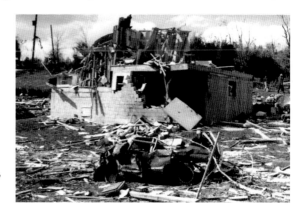

The Smithfield subdivision near Birmingham was decimated by one of the strongest tornadoes on record, an F5. *Courtesy of National Weather Service.*

After the storm passed, leaving the bus unscathed, authorities immediately blocked the entrance to the subdivision, and the driver was unable to drop off the children. They were taken back to the school to await their parents.

The children, like all residents of the area, later learned how lucky they were to escape the tornado's wrath; it was determined to be one of the strongest on record.

Just months before the April 4, 1977 tornado hit, weather radio transmitters had been installed on Birmingham-area towers. This was the first time the system had been used. It saved lives.

J.B. Elliott, a specialist with the National Weather Service in Birmingham, had witnessed the aftermaths of bad storms before. He had helped survey Guin after it was nearly destroyed by an F5 during the 1974 Super Outbreak.

In 1977, if a tornado struck, J.B. was responsible for gathering all pertinent data—number of homes destroyed, lives lost and more—for a publication called *Storm Data*. The task after the F5 that hit Smithfield was daunting.

"It was an enormous task," he said. With the help of civil defense, the precursor to the Emergency Management Agency, and newspaper accounts, J.B. determined the damage that the Smithfield Tornado had left in its wake:

- 22 people dead
- 130 injured
- 150 homes damaged
- 50 homes completely destroyed
- $25 million in damage ($85 to $90 million in 2010)

After the storm, J.B. flew over Smithfield Estates and worked on the ground, taking photos of the devastation. "It was some of the worst damage I've ever seen," J.B. said.

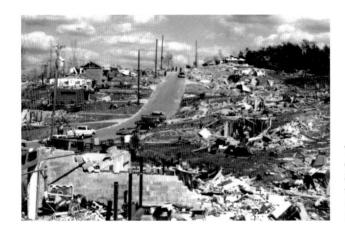

The task of clearing debris in the Smithfield community would be daunting. *Courtesy of National Weather Service.*

J.B. did not learn until after the storm that famed weather scientist Dr. Theodore Fujita, creator of the Fujita Tornado Intensity Scale, was in the skies over Alabama that day, following the F5 Smithfield Tornado and super cell thunderstorm from an airplane.

Fujita tracked the storm from above and then surveyed damage on the ground; he considered that the tornado could have reached an F6 intensity. In the end, it was given an F5 ranking. "It was only the second time he ever considered rating a tornado an F6," J.B. recalled. The first time was in Guin in 1974.

J.B. had never seen anything like the devastation at Smithfield. In some cases, even the cinder blocks of a home's foundation were crushed.

J.B. knew that the impact could have been much worse. "Thirty minutes later and all the children would have been home from school. In two hours, people would have been home from work. The death toll would have been much higher."

Weather historians say that the timely warnings prevented more deaths from the deadly storm. The National Oceanic and Atmospheric Administration had implemented the weather radio program five months before, and warnings were broadcast on the Birmingham KIH-54 transmitter, giving people time to take cover. J.B. read reports from fellow scientists and local law enforcement officials on the weather radio broadcast. "It was the first time we had done a broadcast live. That was reported to have saved a lot of lives."

The tornado left hundreds homeless but also had far-reaching impact: Daniel Payne College near U.S. Highway 78 was so badly damaged that it closed its doors later in the year. It had been in existence for almost one hundred years, since 1880.

The storms in this same system that crossed the South that day also were blamed for the crash of Southern Airways Flight 242, in which seventy-two people were killed, including nine on the ground, and twenty-two injured.

Flight 242 crashed in New Hope, Georgia, on its way from Huntsville, Alabama, to Atlanta. The plane was flying through rain and hail when its engines stopped. There were eighty-one passengers and four crew members on board.

The National Transportation Safety Board determined in its report that "the probable cause of this accident was the total and unique loss of thrust from both engines while the aircraft was penetrating an area of severe thunderstorms."

Six other tornadoes struck northern and central Alabama that day, including five F2 tornadoes and an F3 tornado.

1956: "THERE WAS NOTHING LEFT"

Elizabeth Sheetz was nine years old when a tornado hit McDonald Chapel near Birmingham on April 15, 1956. She remembers the day vividly. She was visiting her grandfather that afternoon and went outside to see what her mother and brother were doing. They were discussing the sky: "The eerie color and the dark, muggy stillness," Elizabeth said.

Her father, grandfather and uncle were in the front yard painting the house.

"All of a sudden my dad yelled, 'Here it comes!' The men ran into the house, and my uncle hollered that we should all run to the storm shelter up the street. My dad said we would never make it, that it was too late," she recalled. "At that point, it took three grown men pushing with all their might to close the back door of my grandfather's house."

Nine people, five adults and four children took cover in the hallway. "In the distance, I could hear a roar. This roar is just as you hear a roar of wind through the trees that eventually dies down. This roar did not die down. It just got louder and louder. Suddenly, a blast of 'emptiness' occurs. No roar; only the sound of the house creaking and the clanging and pinging of debris being blown around."

And then it was over. The home was safe, as were all of its occupants. The roof on the house across from Elizabeth's grandfather's was blown off, though. Elsewhere in McDonald Chapel, the devastation was much worse.

"We were the lucky ones," Elizabeth said. "My dad, grandfather and uncle searched for victims and cleared roads so that rescue vehicles could

reach the more devastated areas. I will always remember the sirens of the ambulances and fire trucks."

The devastation was so widespread that the National Guard "placed a heavy guard on the area, requiring all persons to carry an identification card," according to an April 16, 1956 report by United Press International.

The wire service reported that McDonald Chapel was hardest hit:

> *McDonald's* [sic] *Chapel bore the brunt of a 450 mile squall front that raked the Southeast Sunday. A tornadic wind slammed through the heard of the mining community of 1,000, leaving a fourth of the residents homeless. The houses looked like piles of timber in a lumberyard. Over a wider area, homes were overturned or battered. A crew of fifty searchers forced their way into rooms buried under debris and pried up mounds of planks in their hunt for victims. They found one body draped in a tree.*

The 1956 tornado was rated an F4 on the Fujita scale. It killed 25 people and injured as many as 200. It struck just west of downtown Birmingham at about 3:00 p.m., first hitting the community of Pleasant Grove and then following a twenty-one-mile path through McDonald Chapel, Edgewater, Pratt City, Village Creek and Tarrant before lifting near Trussville.

This tornado passed one to two miles north of what was then the Birmingham-Shuttlesworth International Airport.

As many as four hundred homes across Jefferson County were damaged or destroyed. It was the deadliest tornado to strike the United States in 1956. The 1950s proved to be a deadly decade for tornadoes, with killer tornado outbreaks around the country in 1952, 1953, 1955 and 1957. Weather bureaus began keeping records of tornadoes in 1950.

Sue Hilton Sellers was sixteen on April 15, 1956, when the tornado hit McDonald Chapel. Sue, her parents and younger brother had just arrived home from church that Sunday. Sue's mother made ham and potato salad because the family was having guests for lunch, including the pastor of their church.

Sue had been invited to go to a friend's home nearby where a few of her classmates were gathering. "Daddy wouldn't let me go," Sue said. "We had company. He said I could go after they left."

Ten people were in the three-story home that sat on a hill in McDonald Chapel when the storm hit, including Elizabeth, her parents, John Henry and Hazel, and her younger brother, Terry.

The family survived unscathed but emerged to find their community forever changed. Power was out for miles, and cars could not navigate

because of the trees and debris blocking the roads. The Hilton family walked to Wylam to use a phone to let Sue's grandmother know that everyone was unhurt. They arrived back home and invited anyone who was mobile to come to the Hilton home for a church service.

"We had church in our basement and served the ham and potato salad," Sue said. In following days, Sue and her mother worked in the basement of their home, washing clothing and blankets people found; then they handed out items, including shoes, to those who needed them.

The National Guard quickly arrived and blocked entrance to the community. Sue said that residents inside were not allowed to wander from home to home, so she could not check on her friend whose home she was supposed to visit.

Later, she discovered that her friend's home had been hit. Four of her friends had been at the gathering, including a boy who had sheltered her friend's eighteen-month-old brother during the storm. Her friend's two sisters were hospitalized with injuries for several days.

Sue was grateful that she hadn't been with her friends. "There was nothing left of that house," she said.

BY THE NUMBERS
Deadliest Birmingham-area tornadoes.

According to the Tornado Project, these tornadoes caused the most deaths and devastation in the Birmingham area, which includes Jefferson County and parts of Shelby County (Fujita rankings of tornadoes prior to 1950 given based on newspaper accounts):

February 19, 1884
Thirteen deaths, F4, Jefferson and St. Clair Counties. A tornado touched down south of Birmingham, near Oxmoor, and then cut a path northeast into Brocks Gap before dissipating near Branchville.

March 25, 1901
Seventeen deaths, F3, Jefferson County. The final death toll may have been more than twenty people from this tornado that cut through southern Birmingham to Avondale and Irondale.

April 24, 1908
Thirty-five deaths statewide, Dixie Outbreak, F4, Walker, Jefferson,

Blount, Marshall and DeKalb Counties. Two people were killed at Warrior in Jefferson County. The other deaths occurred outside the Birmingham area.

May 27, 1917
Twenty-seven, F4, Jefferson and Blount Counties. These likely could have been separate tornadoes. The path of destruction was from Sayre and through Bradford.

May 5, 1933
Twenty-one deaths, F4, Bibb and Shelby Counties. A tornado hit south of Brent and moved northeast to the edge of Centerville. Five were killed in Brent, two in Colemont and fourteen at Helena. Helena was hardest hit: 150 people were injured, and the majority of the city's residents were left homeless.

April 15, 1956
Twenty-five deaths, F4, Jefferson County. McDonald Chapel was devastated. About four hundred buildings were damaged or destroyed.

April 4, 1977
Twenty-two deaths, F5, Jefferson County. At the time, the strongest tornado to hit the area moved from northwest of downtown Birmingham to Tarrant, destroying 167 homes and damaging 48 more. Daniel Payne College sustained $1.3 million in damage and later closed, while the total damage estimate for the entire tornado path was $15 million.

April 8, 1998
Thirty-five deaths, F5, Jefferson County. Oak Grove and Edgewater communities devastated.

Chapter 9
FREAKS OF NATURE

Strange but True Tornado Tales

The force of tornadic winds is so strong that it often defies the rules of nature. Tales of straw driven into trees or two-by-fours lodged in cinderblocks or car tires are part of tornado lore. Here are some stories from Alabama storms—most were reported in reliable newspapers of the day; some have been handed down as family stories.

MARCH 21, 1932

The *Limestone Democrat* reported on March 24, 1932, that "many freakish pranks were played out by the winds. One person having a piece of wood blown through his leg."

During the Dixie Outbreak, a home in Columbiana had been completely destroyed. The kitchen table stood amid the rubble. A drawer in the table's side had been sucked out by the winds, but thirty-six eggs were unbroken on its top.

One account reported that a severely injured eighty-three-year-old woman named Mrs. Headly of Chilton County told her brother where she had buried an earthen pot containing $2,700 in gold. He found the gold before his sister died.

This hen was still sitting on her unbroken eggs after her roost was blown from the side of the barn at the Latham farm after the 1932 tornado. The hen and eggs were auctioned for $242, which went to support Latham orphans. *Courtesy of Analiese Schell/Latham family collection.*

At the Latham home in Stanton, a wooden box made as a hen's roost was ripped from the wall of the barn as it collapsed. The hen and eggs, tossed to the ground in the box, survived unharmed. They were auctioned for $242 to raise funds for the four surviving Latham children, who lost their parents, siblings and home.

After the 1932 tornadoes passed through, a check from a Paint Rock home was found in Athens, Tennessee, 105 miles away.

The March 24, 1932 edition of the *Montgomery Advertiser* reported that Joe Bratton of Chilton County, who was injured during the storm three days before, regained consciousness in a Birmingham hospital and remembered that he had left $600 in a pair of pants hanging in a closet. He asked his son to try to find the money. The pants were stuck in a fence with the $600 still in the pocket.

APRIL 15, 1956

A home in McDonald Chapel outside of Birmingham was flipped on its foundation—the front door faced toward the backyard after the 1956 tornado passed through.

APRIL 3, 1974

In the 1974 outbreak of tornadoes that decimated several Alabama towns, an oddity was preserved for posterity from the Xenia, Ohio tornado. A piece of lumber with a quarter driven into it is located in a museum in the town, which had the most fatalities during the outbreak.

The *Anniston Star* reported the day after the April 3, 1974 Super Outbreak: "In Jasper, John Simmons said he and six members of his family heard the storm's noise and before they could take cover, their house was lifted off its foundation, banged around between two rows of trees in the yard and set back down. They all escaped injury." The article also reported that "Mr. and Mrs. Al Jones, operators of an ambulance service, drove two new ambulances toward a demolished trailer park near Athens but had to abandon the vehicles which were destroyed seconds later by another twister."

NOVEMBER 15, 1989

Tara Alt and her dad, Emile, returned to the scene of the tornado on Airport Road in search of the car she had parked at Jones Valley Elementary School, where she was working when the storm hit. Her college textbooks, as well as the veil that she wore the following weekend in her wedding, were in the trunk. Searching through the rubble in the devastated area, Tara heard a radio playing. She thought that the work crews must be listening to music, but when she and her father finally found her car, she saw that the in-dash radio had been ripped from her car and was dangling from a rearview mirror. The ignition was not on and the radio was not attached, but it was playing.

Jeanette Johnson rushed to get inside her home on Toney Drive in Huntsville before the November 15, 1989 tornado hit. Frantically, she tried to get her key in the front door's lock, but by then the winds were too high. She saw a black cloud bearing down on her and pressed her body tight against the door, shielding the front of her body. Suddenly, she was pummeled with flying debris. When it was over, Jeanette looked around her and saw that much of her house was gone. The front door was still standing, and on its front a clear outline of her body could be seen: It was white where her body had been huddled—the rest was coated by shards of glass, wood and debris. She credited her London Fog all-weather coat for

her lack of injuries. After hearing the account, the president of London Fog sent Jeanette a new coat.

A sealed box of chocolates, a Whitman's sampler, was found in Jackson County. On it was a price sticker from Thomas Discount Drugs in south Huntsville. Jackson County is about forty-five miles away.

At an office in Crestwood Professional Center, wallpaper was stripped from the walls, yet the framed diplomas remained.

Millie Goldstein's car was lifted by the winds and deposited onto the rubble of the Huntsville Utilities substation. She called out for help until a utilities worker rescued her with a bucket truck.

Riley's Food Store was completely demolished. Amid the rubble, one wall of shelves still stood, lined with untouched soft drink bottles.

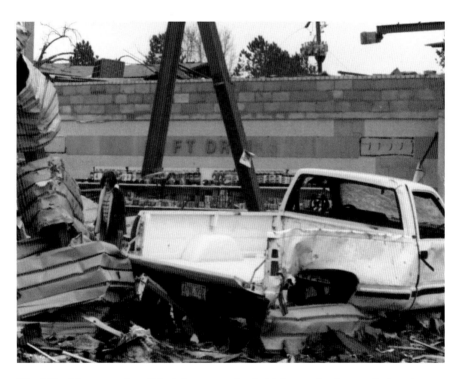

Riley's Food Store was demolished, but a row of soft drinks remained untouched on the shelves. *Courtesy of Jim Pemberton.*

After three churches were struck in the 1989 tornado in Huntsville, Sunday school rosters, hymnals and Bibles were found as far as Hazel Green. A choir robe from Trinity United Methodist Church that was still in its dry cleaning bag was found with the bag intact and the robe still clean.

APRIL 8, 1998

In Edgewater, a home was destroyed when it was pounded with bricks from the Methodist church next door. Only a part of the kitchen wall and a counter remained, yet none of the dishes on the counter were broken.

Hootie Shoemaker's sister-in-law, Barbara Morgan Shoemaker, a widow, was home alone when the April 8, 1998 tornado hit near Birmingham. Barbara had been sick and had spent much of her time in bed, with only her black lab for company. As the storm approached, though, she rose from her bed and was standing in a door frame when it hit. When it had passed, much of her home was gone. The door frame remained. The head of her bed remained where it had been, but the foot of the bed was blown away with the storm. Her faithful dog was never found.

The April 8 tornado that struck Concord demolished the backyard garage of Elizabeth Salter and pulled up every shrub that had been planted beside it. But the car inside the garage remained, untouched by the F5 winds.

Some letters written by the daughter of Barbara Morgan Shoemaker were found in Gadsden, about eighty miles from where the April 8, 1998 tornado had demolished the Shoemaker home outside of Birmingham. Some checks from the home were found in north Georgia and mailed back to the family.

VARIOUS TORNADOES

According to an 1884 story from the *Times Democrat* in Huntsville, "A baby was carried several miles and dropped in the woods where it was found alive this morning."

The *Atlanta Constitution* reported on April 9, 1903, that the town of Hopewell was wiped out by a storm. It noted that Henry McCoy was found dead,

clasping his baby in his arms in an effort to get her out. Two children survived but died later in the day.

The *Indiana Democrat* in Pennsylvania reported on the January 1904 tornado that struck Moundsville: "Through terror, a father, mother and three children fled from their home to seek refuge, and in their excitement left a 5-year-old boy in bed. He was pulled from beneath some timber and thus far it is impossible to find any other member of the family."

On April 1, 1912, in Dickson, Tennessee, a box with a hen was carried two hundred yards without harming the hen.

On March 21, 1913, a pillow was carried twenty miles from Scyrene to Lower Peach Tree, Alabama.

The *Atlanta Constitution* reported on March 23, 1913, about the March 21 Lower Peachtree tornado: "In backyard of the Bryant home, buried in debris, was a chicken coop, not a splinter awry. Within it was a goose sitting meekly upon a dozen eggs which she had not left." The article also noted that "W.S. Irby, wife and child had an almost miraculous escape from death. While the house was being wrecked by the tornado they leaped from a window to a small chicken house in the yard, where some heavy timbers had been placed, and hung there while their home was swept into the Alabama river by the gale. None were seriously injured."

The book *The True Story of Our National Calamity of Flood, Fire and Tornado* by Logan Marshall, published in 1913, reported this damage from a March 21, 1913 storm:

> *Weird tales of horror and misery attended the tornado which swept over the little town of Lower Peachtree, Alabama, on Friday, March 21st, wrecking the entire village. After the tornado had passed, corpses with hair stripped from heads and divested of every thread of clothing were picked up… Chickens and hogs stripped of feathers and hair wandered in bewilderment among the ruins. Nailed unerringly into trees cleaned of their bark were pickets from fences that had been swept away.*

On February 25, 1968, the *Tuscaloosa News* reported that in Hale County near Faunsdale "in an old tree stump, a horse collar, a dead pig and a 3-year-

old baby were found jammed together. Several people were found several hundred yards away after the storm. An iron pot sailed through the air nearly a half mile."

In Lawley, Alabama, a car was picked up and carried fifty feet, according to a story in the *Shelby County Reporter* on September 7, 1972.

An April 21, 2009 article in the *Birmingham News* stated that "at least 14 confirmed tornadoes hit multiple counties in Alabama on Sunday, the National Weather Service said Monday night. Sunday's storms killed two people in North Alabama as well as killed 90,000 chickens when chicken houses on two Blount County farms were destroyed, authorities said."

The word "tornado" was banned during weather broadcasts from 1886 to 1952, according the USA Today *Weather Book*. In the 1880s, when weather alerts were issued by the army, John P. Finley of the Signal Corps gave generalized forecasts on which days tornadoes were most likely to occur. This led to forecasts of severe weather when often none arose. In 1886, the army ended Finley's program and banned use of the word from forecasts because "the harm done by a [tornado] prediction would eventually be greater than that which results from the tornado itself." The army was concerned that the word itself could cause a panic and ensuing stampede. When the U.S. Weather Bureau, the precursor to the National Weather Service, took over forecasting duties from the army, the ban was lifted.

On May 3, 1999, researchers using a mobile Doppler radar got a rare surprise: the equipment had managed to record a wind speed of 318 miles per hour in a tornado that hit Oklahoma City. The speed was noted at about two hundred feet in the air rather than at ground level, but scientists were enthralled by the occurrence because the tornado had to pass exactly above the equipment to get a direct reading. Typically, wind speeds are determined by damage surveys after the storms, and the Fujita rankings are assigned.

Chapter 10
How to Be Safe in a Storm

The National Oceanic and Atmospheric Administration wants people to have current information about tornadoes and proper safety information.

TORNADO MYTHS AND FACTS

Myth: Areas near rivers, lakes and mountains are safe from tornadoes.
Fact: No place is safe from tornadoes. The regions hit most often in Alabama by tornadoes are mountainous.

Myth: The low pressure accompanying a tornado causes buildings to "explode" as the tornado passes overhead.
Fact: Violent winds and debris slamming into buildings cause the most structural damage.

Myth: Windows should be opened before a tornado approaches to equalize pressure and minimize damage.
Fact: Opening windows allows damaging winds to enter the structure. Keep windows closed and go to a safe place in the home.

Myth: If driving, you should get out of the car and take refuge under a highway overpass.

Fact: An overpass may be one of the worst places to seek shelter from a tornado. It puts people at greater risk of being killed or seriously injured by flying debris. The safest course of action when a tornado approaches is to get out of the tornado's path or seek shelter in a sturdy, well-constructed building. Lying flat in a ditch, ravine or below-grade culvert also offers protection from flying tornadic debris. Do not try to outrun a tornado in a car.

SAFETY BEFORE THE STORM

- Develop a plan for your family for home, work and school and for when you are outdoors.
- Have frequent drills.
- Know the county in which you live and keep a highway map nearby to follow storm movement from weather bulletins.
- Have a NOAA Weather Radio with a warning alarm tone and battery back-up to receive warnings.
- Listen to radio and television for information.
- If planning a trip outdoors, listen to the latest forecasts and take necessary action if threatening weather is possible.

AFTER A WARNING IS ISSUED

- In a home or building, move to a previously designated shelter, such as a basement.
- If an underground shelter is not available, move to an interior room or hallway on the lowest floor and get under a sturdy piece of furniture.
- Stay away from windows.
- Get out of automobiles.
- Do not try to outrun a tornado in your car; instead, leave it immediately.
- Mobile homes, even if tied down, offer little protection from tornadoes and should be abandoned.

SEVERE WEATHER GLOSSARY

Tornado Watch: Tornadoes are possible in your area. Remain alert for approaching storms.

Tornado Warning: A tornado has been sighted or indicated by weather radar. If a tornado warning is issued for your area and the sky becomes threatening, move to your previously designated place of safety.

Severe Thunderstorm Watch: Severe thunderstorms are possible in your area.

Severe Thunderstorm Warning: Severe thunderstorms are occurring in your area.

BE ALERT

Watch for:
- Dark, often greenish sky
- Wall cloud
- Large hail
- Loud roar, similar to the sound of a freight train

Who are the most at risk?
- People in automobiles
- The elderly, the very young and the physically or mentally impaired
- People in mobile homes
- People who may not understand the warning due to language barriers

Sources

BOOKS

April 3, 1974: The Alabama Tornadoes. Souvenir booklet. Sun City, AZ: C.F. Boone, 1974.

Bose, Joel C., ed. *Notable Men of Alabama.* Vol. 2. Spartanburg, SC: Reprint Company, 1904.

Bragg, Rick. *Somebody Told Me.* Story on Piedmont Tornado of 1994. New York: Vintage Books, A Division of Random House, 2000.

Clem, Dale. *Winds of Fury, Circles of Grace.* Nashville, TN: Abingdon Press, 1997.

Huntsville Tornado: November 15, 1989, 4:37 P.M. Souvenir booklet produced by the *Huntsville Times* and the *Huntsville News.* Sun City, AZ: C.F. Boone, 1990.

Latham, Jackson Lewis, Jr. *My God! It's a Cyclone: A Survivor's Perspective on the Long Term Effect of Nature's Fury.* Bloomington, IN: AuthorHouse, 2005.

Levin, Mark. *F5: Devastation, Survival, and the Most Violent Tornado Outbreak of the Twentieth Century.* New York: Miramax Books, 2007.

Owen, Thomas McAdory. *History of Alabama and Dictionary of Alabama Biography.* Chicago, IL: S.J. Clarke Publishing Company, 1921.

NEWSPAPERS

Anniston (AL) Star
Athens (AL) News Courier
Birmingham (AL) News
Huntsville (AL) News
Huntsville (AL) Times

TELEVISION

Tenth Anniversary Special of 1994 Tornadoes. With meteorologist James Spann, host. ABC 33/40 television station, Birmingham, Alabama. http://www.youtube.com/watch?v=JJID5zcr6MU (part one).

Tenth Anniversary Special of 1994 Tornadoes. With meteorologist James Spann, host. ABC 33/40 television station, Birmingham, Alabama. http://www.youtube.com/watch?v=JJID5zcr6MU (part two).

Tenth Anniversary Special of 1994 Tornadoes. With meteorologist James Spann, host. ABC 33/40 television station, Birmingham, Alabama. http://www.youtube.com/watch?v=n-fwJk32DWQ (part three).

WEATHER AND HISTORICAL SOURCES

Alabama Department of Archives and History. Photos.
Limestone County Emergency Management Agency. Interviews and photos.
National Oceanic and Atmospheric Administration. Online documents.
National Weather Service, Birmingham. Interviews, online records and photos.
National Weather Service, Huntsville. Interviews, online records and photos.

WEBSITES

GenDisasters. www3.gendisasters.com.
Tornado Project Online. http://tornadoproject.com.

ABOUT THE AUTHOR

Kelly Kazek is managing editor of the *News Courier* in Athens, Alabama. In her more than two decades as a journalist, she has won more than 120 national and state press awards. She is the author of two other books, *Fairly Odd Mother: Musings of a Slightly Off Southern Mom*, a collection of her syndicated humor columns, and *Images of America: Athens and Limestone County*. She lives in Madison, Alabama, with her daughter Shannon, their beagle Lucy and cats Mad Max and Luvey.